HONG KONG

architecture & design

Edited by Katharina Feuer
Written by Anna Koor
Concept by Martin Nicholas Kunz

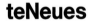

content

to see . culture & education

to see . public

content

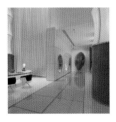
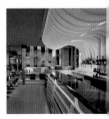

to go . wellness, beauty & sport

to shop . mall, retail, showrooms

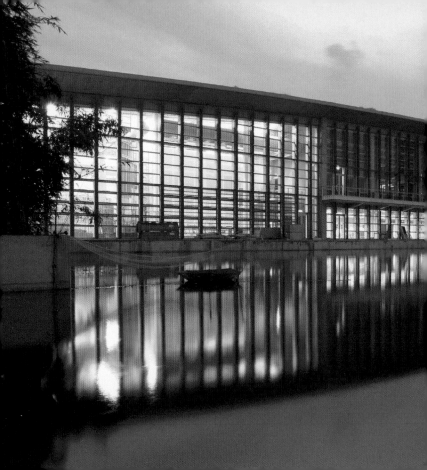

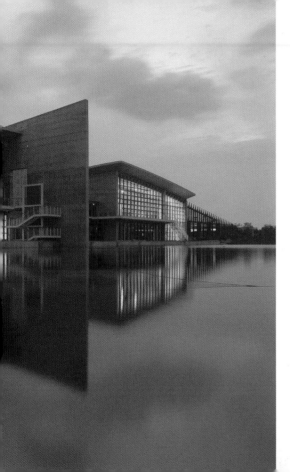

introduction

Hong Kong's reputation as a hyper-dense, vertical metropolis describes only one dimension of its reality. The legacy of iconic architecture by I. M. Pei and Sir Norman Foster, inherited in the 1980s, were tough acts to follow. But many modern masterpieces later and the city has lost none of its vibrancy. Glittering structures showcase a wealth of design talent nurtured in Hong Kong. Next to the new architecture co-exist the old buildings, both forming an inspiring contrast. As fast as the city looms overhead, it vanishes into rural enclaves and sleepy fishing villages.

Hong Kongs Image einer dicht bebauten, vertikal ausgerichteten Metropole macht nur eine Dimension ihrer Realität aus. Das architektonische Vermächtnis der Baumeister I.M. Pei und Sir Norman Foster setzte in den 1980er Jahren hohe Maßstäbe für die nachfolgenden Architekten. Doch das Heer neuer Meisterwerke hat die Stadt nur noch dynamischer gemacht. Glitzernde Bauten führen den Reichtum an Design-Talent „made in Hong Kong" vor Augen. Die bestehende alte Architektur bildet zusammen mit der neuen eine inspirierende Mischung. So plötzlich die Stadt in die Höhe wächst, so schnell löst sie sich wieder in ländliche Gebiete und schläfrige Fischerdörfer auf.

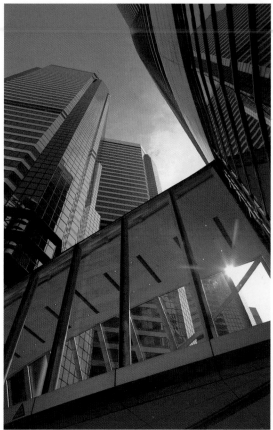

Three Pacific Place

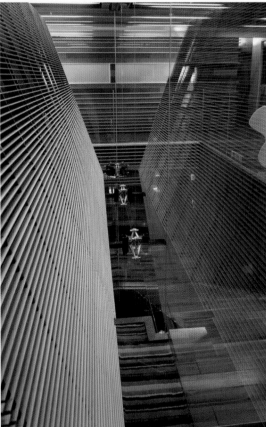

La réputation de Hong Kong d'être une métropole aux constructions denses, tout en hauteur, ne reflète qu'un aspect de sa réalité. L'architecture des années 1980 léguée par les maîtres I.M. Pei et Sir Norman Foster a posé les jalons auxquels se mesurent les architectes suivants. Pourtant la multitude des nouveaux chefs d'œuvre a rendu la ville encore plus dynamique. Des bâtiments étincelants illustrent la richesse des talents du design « made in Hong Kong ». L'ancienne architecture subsiste, associée à la nouvelle, pour constituer un mélange innovant. Aussi soudainement qu'elle pousse en hauteur, aussi vite la ville se dissout-elle dans un paysage rural aux villages de pêcheurs endormis.

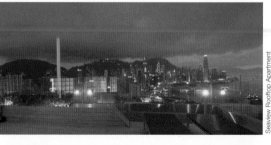

Seaview Rooftop Apartment

La imagen de Hong Kong de metrópoli en un denso paisaje de construcciones verticales es sólo una dimensión de la realidad que ésta encierra. El legado arquitectónico de los maestros constructores I.M. Pei y Sir Norman Foster durante la década de 1980 fijó la escala por la que deberían medirse sucesivas generaciones de arquitectos. Un tropel de nuevas obras maestras contribuyó aún más al dinamismo de la ciudad. Ante la vista se levantan edificios fulgurantes, imagen de un imperio de diseño con talento "made in Hong Kong", cuya fusión con la antigua arquitectura constituye una mezcla inspiradora. Tan pronto la ciudad crece a lo alto como se diluye en zonas rurales y sosegados pueblos de pescadores.

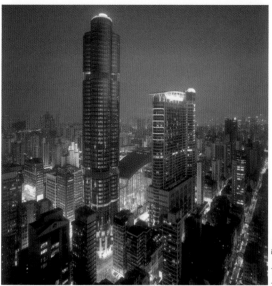

Langham Place

to see . living
 office & industry
 culture & education
 public

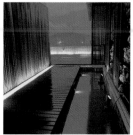
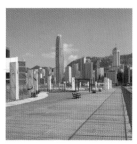
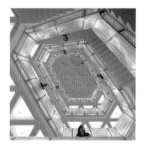
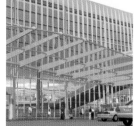
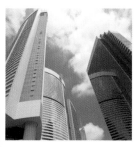

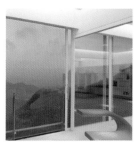

56 Repulse Bay Road

Steve Leung

2004
56 Repulse Bay Road
Repulse Bay

www.steveleung.com

The apartment was remodeled to capitalize on the tropical beachfront views. The space is delineated by furniture and various materials define the sections. Glass encloses the kitchen and en-suite bathroom, extending the perspective of space.

Das Appartement wurde umgebaut, um den Blick auf den tropischen Strand einzubeziehen. Die Möbel gliedern den Raum, und verschiedene Materialien definieren einzelne Abschnitte. Küche und angeschlossenes Badezimmer sind durch Glas abgetrennt, so dass der Raum noch großzügiger wirkt.

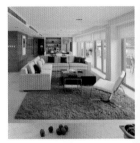

L'appartement a été transformé pour intégrer la vue sur la plage tropicale. Les meubles articulent l'espace et divers matériaux définissent différentes sections. La cuisine et la salle de bain attenante sont séparées par une vitre, rendant l'espace encore plus spacieux.

El apartamento fue transformado con el objeto de maximizar las vistas a la playa tropical. Los muebles desglosan la estancia y diversos materiales definen los espacios. La cocina y el baño adjunto están separados por cristal, dando un efecto de aún mayor amplitud a la habitación.

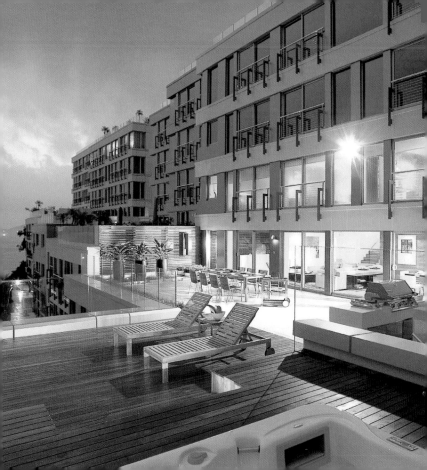

Belleview Drive

Antony Chan, Cream

2004
Repulse Bay

www.cream.com.hk

A contemporary, lively ambience permeates this seafront apartment that reflects the owners' affection for the work of cartoonist Charles Schultz. Images are given a graphic twist with Andy-Warhol-inspired canvases and openness is accentuated by custom-designed patterned glass.

Eine zeitgemäße, lebendige Atmosphäre herrscht in diesem Küstenappartement, das die Vorliebe des Besitzers für das Werk des Cartoonisten Charles Schultz widerspiegelt. Die Bilder stehen in einem Spannungsverhältnis zu Gemälden im Stile Andy Warhols. Nach den Wünschen des Kunden gestaltetes Glas betont die Offenheit des Raums.

Il règne une atmosphère vivante et contemporaine dans cet appartement sur la côte qui reflète la prédilection du propriétaire pour l'œuvre du dessinateur Charles Schultz. Les images forment un contraste avec les tableaux dans le style d'Andy Warhol. Le verre façonné aux gouts du client accentue l'ouverture de l'espace.

Este apartamento costero dominado por un ambiente moderno y vivo, es un claro reflejo de la predilección del propietario por la obra del dibujante de comics Charles Schultz. Sus pinturas están colocadas en un tenso contraste con otras de estilo Andy Warhol. Un cristal añadido según los deseos del cliente acentúa el carácter abierto de la estancia.

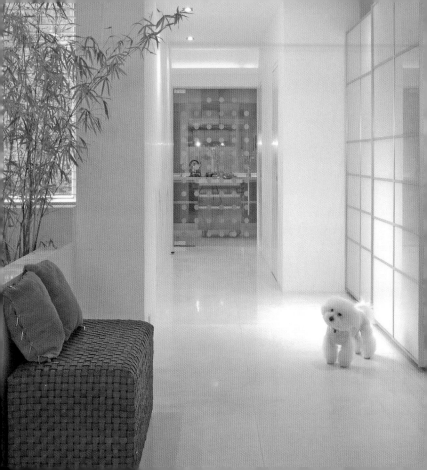

Cypresswaver Villas

Joseph Sy, Jada Lai, Joseph Sy & Associates

2005
Chung Hom Kok

www.jsahk.com

On a hillside over the tranquil waters south of Hong Kong, the resort-like duplex explores openness and privacy. Slatted enclosures, a raised bridge deck, and elongated rectangular pond add to the home's special charm.

Auf einem Hügel über der ruhigen See südlich von Hong Kong liegt das an ein Feriendomizil erinnernde Doppelhaus, offen und doch privat. Einfriedungen aus Holz sowie ein schmales Wasserbassin und eine Brücke tragen zum besonderen Charme des Hauses bei.

Sur une colline au-dessus d'une mer tranquille au sud de Hong Kong se situe ce duplex, tel une résidence de vacances, ouvert et cependant privé. Une haie de lattes en bois, un étroit bassin d'eau et un pont confèrent un charme particulier à cette maison.

En una colina elevada sobre el sosegado mar al sur de Hong Kong se ubica este duplex que recuerda a una vivienda de vacaciones y goza del carácter abierto y privado al mismo tiempo. El cerco de madera y el estrecho estanque con pasarela contribuyen a acentuar el encanto.

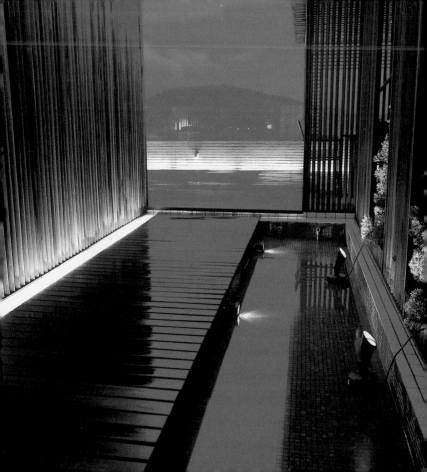

Duplex

Antony Chan, Cream

2002
Brewin Path
The Peak

www.cream.com.hk

Transforming two separate apartments into a modern duplex was a study in flowing lines and linear forms. A balance between modern yet timeless is delicately achieved with a combination of bold elements, quiet materials and a changeable colored lighting program.

Bei dieser Verbindung zweier Einzelappartements zu einem modernen Doppelhaus waren fließende Linien und lineare Formen federführend. Durch die Kombination gewagter Elemente, ruhiger Materialien und einer Beleuchtung mit wechselnden Farben wird ein Gleichgewicht zwischen Modernität und Zeitlosigkeit erreicht.

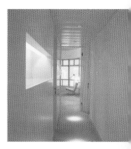

La transformation de deux appartements séparés en un duplex moderne s'est fondée sur des lignes fluides et des formes linéaires. La combinaison d'éléments audacieux, de matériaux apaisants et d'un éclairage aux couleurs changeantes permet d'obtenir l'équilibre entre modernité et intemporalité.

Líneas fluidas y formas lineales fueron la tónica a seguir en el esbozo que llevó a la unión de dos apartamentos para convertirlos en un moderno duplex. La combinación de elementos atrevidos, materiales sosegados y una iluminación de colores variantes crea un equilibrio entre modernidad y atemporalidad.

20

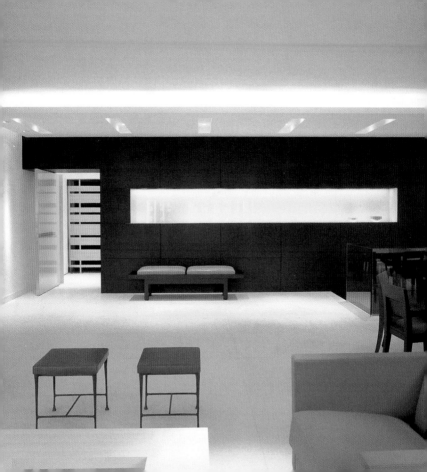

Erba

Paul Kember, KplusK associates

2005
Queen's Road Central
Central

www.erba.hk
www.kplusk.net

The 8 studios and 16 one-bedroom apartments are designed with an eye for abundance of space, light and calmness. Formerly an industrial block, the expanded windows and generous ceiling heights offset an eco-friendly material palette such as bamboo flooring, tumbled marble mosaic and goat-hair carpet.

Die 8 Studios und 16 Ein-Zimmer-Appartements bestechen durch ein großzügiges, helles und ruhiges Design. Die großen Fenster und hohen Decken des ehemaligen Industriegebäudes werden durch umweltfreundliche Materialien, wie einen Fußboden aus Bambus, Marmormosaiken und Teppich aus Ziegenhaar, ergänzt.

Le design de ces 8 studios et 16 appartements d'une pièce privilégie espace, luminosité et tranquillité. Les grandes fenêtres et les plafonds élevés de cet ancien bâtiment industriel sont complétés par des matériaux écologiques tels qu'un plancher en bambou, des mosaïques en marbre et un tapis en poil de chèvre.

Los 8 estudios y 16 apartamentos de una habitación seducen por con su diseño claro, relajado y generoso. Las amplias ventanas y techos elevados de lo que en su día fue un edificio industrial, se han complementado con materiales ecológicos, como los suelos de bambú, mosaicos de mármol y una alfombra de pelo de cabra.

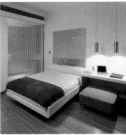

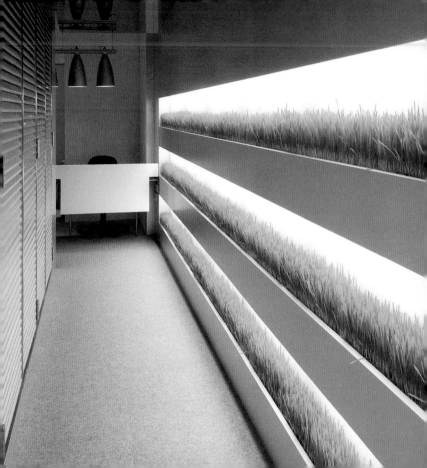

Four Seasons Place
Hong Kong

Rocco Design Ltd.
Bilkey Llinas Design
George Yabu, Glenn Pushelberg, Yabu Pushelberg
Ove Arup & Partners (HK) Ltd. (SE)

2005
8 Finance Street
Central

www.fsphk.com

The 519 six-star serviced suites offer studios, one- or two-bedroom units designed as modern Asian with lavish details. With uninterrupted harbor or cityscape views and linked into the IFC complex, guests are also free to use the expansive leisure facilities including the rooftop pool.

Die 519 Sechs-Sterne-Suiten bieten Studios sowie Ein- oder Zwei-Zimmer-Wohneinheiten mit einem freien Blick auf den Hafen oder die Stadt. Sie sind im modernen asiatischen Stil mit aufwändigen Details ausgestattet. Durch die Anbindung an den IFC-Komplex können die Gäste zahlreiche Freizeitangebote nutzen, wie etwa den Pool auf dem Dach.

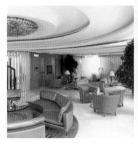

Les 519 suites six étoiles proposent des studios et des appartements d'une ou deux pièces avec une vue dégagée sur le port ou la ville. Elles sont aménagées dans un style asiatique moderne avec des détails sophistiqués. Grâce à la connexion avec le complexe IFC, les hôtes profitent de nombreuses activités de loisirs, telles que la piscine sur le toit.

Las 519 suites de seis estrellas ofrecen estudios y espacios vivienda de una y dos habitaciones, con amplias vistas al puerto o la ciudad. Todas ellas están dotadas de un estilo asiático y elaboradamente detallista. Los huéspedes tienen la oportunidad de disfrutar de las numerosas propuestas de ocio, como es el caso de la piscina en el ático, gracias a que el edificio está comunicado con el complejo IFC.

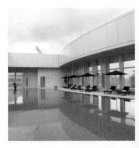

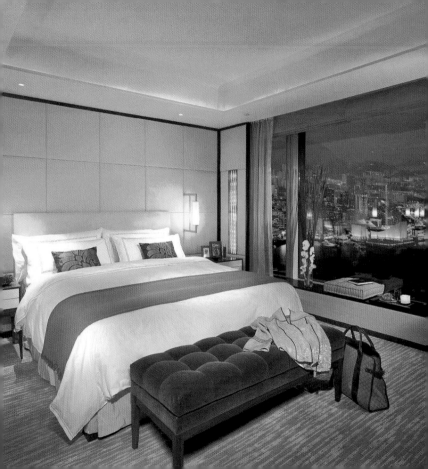

Fung Shui

Jason Caroline Design Ltd.

2003
Cambridge Road
Kowloon Tong

A profound respect for Feng Shui decided the orientation of rooms and furniture, also colors. The concept of Chi—breath of life—guides the circulation between functions, hence the emphasis on circular forms, from the staircase to the sofa in the living room.

Räume und Möbel wurden nach dem Feng-Shui-Prinzip ausgerichtet, die Farben entsprechend gewählt. Das Chi-Konzept – Chi bedeutet Atem des Lebens – sorgt für eine Zirkulation zwischen den Funktionen. So liegt der Schwerpunkt auf runden Formen – von der Treppe bis hin zum Sofa im Wohnzimmer.

Les pièces et les meubles ont été disposés selon les règles du Feng Shui et les couleurs choisies en conséquence. Le principe du Chi – « souffle vital » – assure la circulation entre les fonctions. Aussi l'accent est-il porté sur des formes arrondies – de l'escalier au sofa de la salle de séjour.

Tanto las estancias como los muebles y colores elegidos han sido concebidos siguiendo los principios del Feng Shui. El concepto Chi –que significa aliento de la vida– crea una fluidez entre las diferentes funciones. De ahí que la clave se centre en formas redondeadas, que se dibujan desde la escalera hasta el sofá del salón.

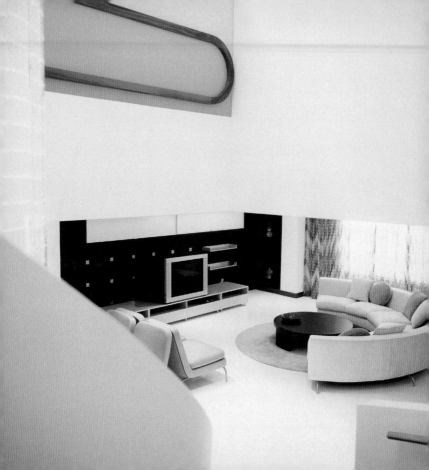

Parkside Serviced Apartments Renovation

Ed Ng, Terence Ngan, AB Concept Ltd.

2005
Parkside
Pacific Place
Wanchai

www.pacificplace.com.hk/living/
suiteoffers.html
www.abconcept.com.hk

The new generation Pacific Place Apartments convey a sumptuous slant on modern Asian design. Bespoke furniture and specially commissioned artwork adorn the 27 residential suites, whilst sliding doors and walls separate and combine spaces, for privacy or sociability.

Die Pacific Place Appartements der neuen Generation legen viel Wert auf modernes asiatisches Design. Maßgefertigtes Mobiliar und speziell angefertigte Kunstwerke zieren die 27 Wohnsuiten. Schiebetüren und Wände trennen und verbinden die Räume, sorgen für Privatsphäre oder Geselligkeit.

Les appartements Pacific Place de la nouvelle génération affectionnent un design asiatique moderne. Un mobilier fabriqué sur mesure et des œuvres d'art spécialement créées décorent les 27 suites résidentielles. Des portes coulissantes et des cloisons servent à séparer ou relier les pièces pour ménager espace privé ou convivialité.

Los Pacific Place Appartments de la nueva generación dan particular importancia al diseño asiático y moderno. Las 27 suites vivienda están vestidas de mobiliario a medida y obras de arte concebidas especialmente para el lugar. Los espacios están separados y enlazados por puertas correderas y paredes, proporcionando al mismo tiempo privacidad y sensación de compañía.

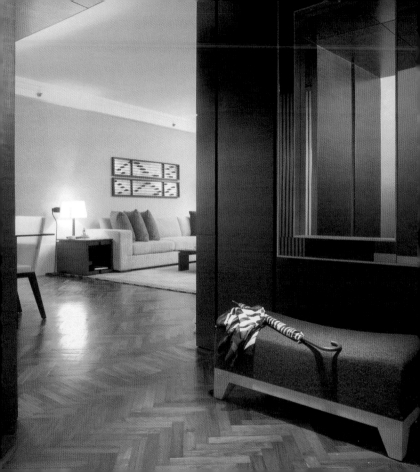

Peak House

Antony Chan, Cream

2003
Peel Rise
The Peak

www.cream.com.hk

The house has spectacular views from its hillside spot. The primary living spaces are defined by contrasting materials. Rooms flow into each other effortlessly with subtle changes in floor and ceiling levels announcing different functions.

Das Haus bietet dank seiner Hanglage einen spektakulären Blick. In den Hauptwohnräumen wurden kontrastierende Materialien eingesetzt. Die Zimmer gehen mit feinen Veränderungen des Bodens zwanglos ineinander über, auch die jeweilige Deckenhöhe weist auf die unterschiedlichen Funktionen hin.

Située à flanc de colline, la maison offre une vue spectaculaire. Dans les pièces principales, des matériaux contrastés ont été utilisés. Les pièces dont les sols présentent de subtiles variations se suivent harmonieusement. De même, la hauteur des plafonds annonce à chaque fois des fonctions différentes.

Su ubicación en la ladera dota a la casa de unas vistas espectaculares. En las estancias principales de la vivienda se han integrado materiales creando contrastes. Las habitaciones se distribuyen libremente una tras la otra distinguiéndose por ligeras modificaciones del suelo. Las respectivas alturas del techo indican también las diversas funciones.

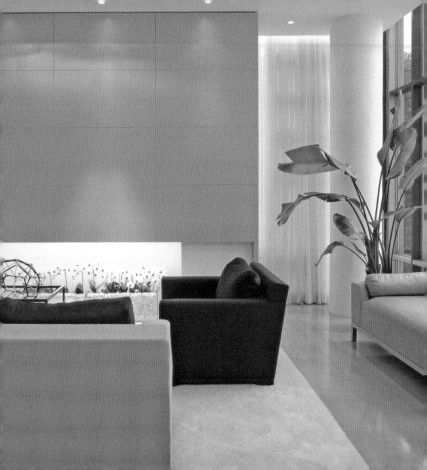

Sandra's Apartment

Edge Design Institute Ltd.

2004
Old Peak Road
Mid-level

www.edgedesign.com.hk

Designed for ultimate home entertaining, flexibility is key. Besides the retractable bed and table, a sculptural wall hides evidence of domesticity—wardrobe, shelves, storage—leaving the modular sofa, bar and views of The Peak as the focus.

Da es für das ultimative Partyvergnügen zu Hause entworfen wurde, ist Flexibilität ein Muss. Bett und Tisch sind einziehbar, und eine plastische Trennwand verbirgt die Anzeichen häuslichen Lebens – Garderobe, Regale und Abstellraum. So bilden das wandelbare Sofa, die Bar und die Aussicht auf The Peak den Mittelpunkt.

Pour des réceptions à la maison idéales, il faut beaucoup de souplesse. Le lit et la table sont escamotables et un paravent esthétique masque les éléments de la vie quotidienne – vestiaire, étagères et rangement – focalisant l'attention sur le canapé convertible, le bar et la vue sur The Peak.

El concepto de flexibilidad es obligado, teniendo en cuenta que fue diseñada para vivir la fiesta en su máxima expresión en casa. La cama y la mesa son plegables y cuenta con una pared separadora de plástico que oculta todo aquello que suene a casa habitada: percha, estanterías y trastero. De esta forma el centro de atención se dirige hacia el sofá-cama, la barra de bar y las vistas al The Peak.

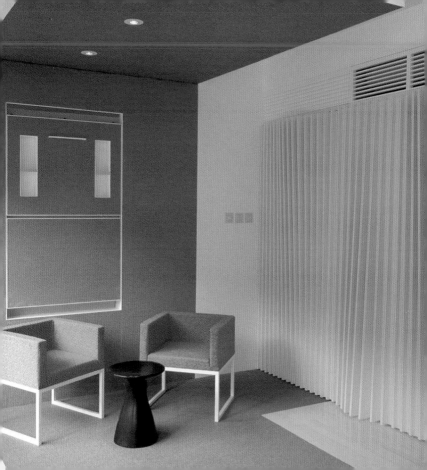

Seaview Rooftop Apartment

Laurence Liauw, Hae Won Shin, Design Architects
JMK Consulting Engineers Ltd. (SE)

2005
28A Seaview Gardens
Cloud View Road
North Point

The living area is linked to the roof terrace via a glass-block stairwell, inviting natural light into the dining room. A floating Korean staircase is anchored by curtain wall fixing bolts, echoing other robust materials such as limestone, teak and stainless steel.

Der Wohnbereich ist mit der Dachterrasse durch einen gläsernen Treppenschacht verbunden, so dass Tageslicht das Speisezimmer durchflutet. Die koreanische Treppe ist mit Befestigungsbolzen für Vorhangfassaden fixiert. Auch andere robuste Materialien, wie Kalkstein, Teak und rostfreier Stahl, wurden verwendet.

Les pièces à vivre sont reliées à la terrasse sur le toit par une cage d'escalier vitrée, qui inonde de lumière la salle à manger. L'escalier coréen est fixé par les boulons de serrage employés pour les façades-rideaux. D'autres matériaux robustes tels que la pierre à chaux, le teck et l'acier inoxydable ont été utilisés.

El espacio de vivienda está unido a una azotea a través de un hueco de escaleras de cristal, con lo que la luz diurna inunda el comedor. La escalera coreana ha sido fijada con pernos de sujeción para fachadas de cortina. También se han empleado otros materiales robustos, como la caliza, la teca y el acero inoxidable.

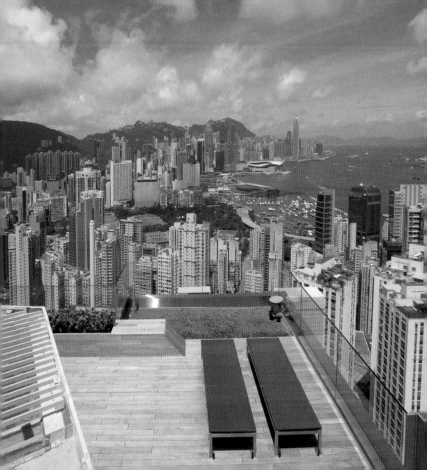

Subliminal

Johnny Kember, KplusK associates

2005
Mount Kellet Road
Kellet Grove

www.kplusk.net

Baring the structure back to its skeleton, a new relationship evolves with the exterior, establishing an architecture whose atmosphere is dependent on the surrounding nature. Spaces are defined by various types of glass creating a complex interplay of depth and transparency.

Die Struktur wurde auf ihr Skelett reduziert, wodurch eine neue Beziehung zur Außenwelt entstand. Die Atmosphäre dieser Architektur hängt somit von der umgebenden Natur ab. Verschiedene Glasarten definieren die Räume und erzeugen ein komplexes Wechselspiel zwischen Tiefe und Transparenz.

La structure a été réduite à son squelette, établissant ainsi une nouvelle relation avec le monde extérieur. L'ambiance créée par cette architecture dépend ainsi de la nature environnante. Différents types de verre caractérisent les espaces et créent une interaction complexe entre profondeur et transparence.

La estructura se redujo al esqueleto creando un nuevo vínculo hacia el exterior. A consecuencia de ello la atmósfera que transmite esta arquitectura se desprende del espacio natural que le rodea. Las estancias están definidas por diversos tipos de cristal que proporcionan con complejo juego de transparencia y profundidad.

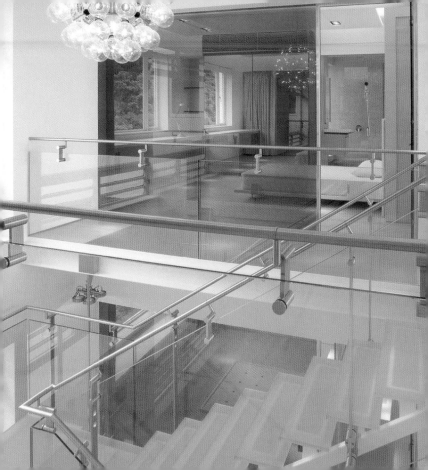

AIG Tower

Skidmore, Owings & Merrill LLP

2005
1 Connaught Road
Central

www.som.com

The 36-story geometric form is a composition of two interlocking squares, responding to its pivotal position between The Peak, the harbor, and an oasis of public space. The tower, linked via bridges into Central's elevated pedestrian network, unfurls towards the sea like a sail.

Das 36-stöckige, geometrische Gebäude ist eine Komposition aus zwei ineinander greifenden Rechtecken. Es steht im Mittelpunkt von The Peak, dem Hafen und einer öffentlichen Erholungsoase. Der Turm, durch Brücken mit den erhöhten Fußgängerwegen des Central-Districts verbunden, entfaltet sich zum Meer hin wie ein Segel.

Ce bâtiment géométrique de 36 étages est composé de deux rectangles imbriqués. Il est au centre de The Peak, du port et d'une oasis de détente destinée au public. La tour, reliée par des ponts aux passages pour piétons surélevés du Central District, se déploie, telle une voile, en direction de la mer.

El edificio geométrico de 36 plantas es una composición de dos rectángulos insertados y constituye el centro entre The Peak, el puerto y un oasis de ocio público. La torre, unida a través de puentes al paso de peatones elevado del Central-District se abre al mar como si de una gran vela se tratase.

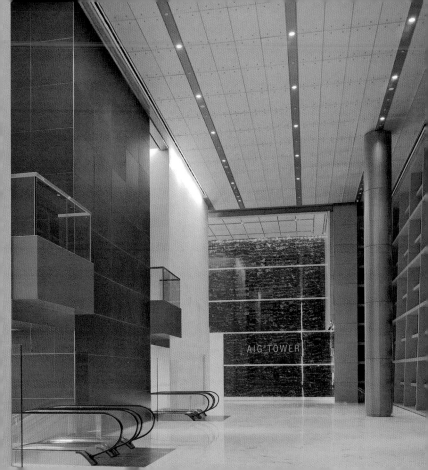

Chater House

Kohn Pedersen Fox Associates PC
Ove Arup & Partners (HK) Ltd. (SE)

2002
11 Chater Road
Central

www.kpf.com

The 30-story development mixes business and retail uses in a geometric glass tower offset by a transparent vertical light box. A three-level podium mediates with the intimate scale of the street and links into adjacent properties via a network of bridges.

In den 30 Etagen des geometrischen Turms sind verschiedene Unternehmen und Geschäfte untergebracht. Einen Kontrast bildet die durchsichtige, vertikale Leuchteinheit. Ein dreistöckiger Vorbau leitet zu der schmalen Straße über und bindet zugleich die angrenzenden Gebäude durch ein Netzwerk von Brücken an.

Cette tour géométrique de 30 étages abrite divers commerces et entreprises. Le puits de lumière vertical transparent crée le contraste. Un bâtiment de trois étages en saillie conduit à la petite rue et assure la liaison avec les bâtiments voisins par un réseau de ponts.

Esta torre geométrica de 30 plantas alberga diversas empresas y comercios. El contraste lo crea un foco de iluminación vertical y transparente. La construcción saliente de tres pisos conduce a la estrecha calle y enlaza con los edificios colindantes a través de una red de puentes.

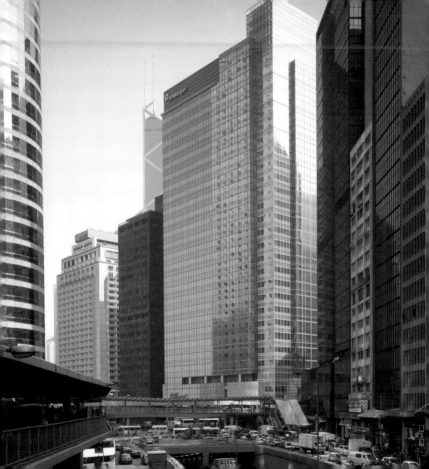

Drum Music Recording Studio

Johnny Kember, KplusK associates

2005
Causeway Road
Causeway Bay

www.kplusk.net

The two studios are separated by the main sound booth, which is precisely engineered to avoid sound leakage without losing eye contact. Despite this extreme division of space, there is a sense of seamless openness that pervades the whole environment.

Die beiden Studios werden durch eine große schalldichte Kabine getrennt, die speziell entworfen wurde, um Klangverlust zu vermeiden und den Sichtkontakt zu optimieren. Trotz dieses auffälligen Einbaus wirkt der Raum dank der fließenden Übergänge offen.

Les deux studios sont séparés par une grande cabine insonorisée qui a spécialement été conçue pour éviter la perte de son et optimiser le contact visuel. Malgré cette installation marquante, l'espace paraît ouvert grâce aux jonctions fluides.

Ambos estudios están separados por una gran cabina insonorizada, que fue concebida especialmente con el fin de evitar la pérdida de sonido y alcanzar un contacto visual óptimo. A pesar de ser una construcción tan compleja, el espacio transmite una sensación de amplitud gracias a pasos de transición fluidos.

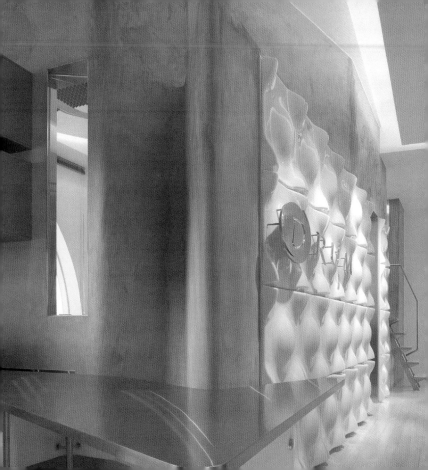

EMSD Headquarters

Architectural Services Department, HKSAR Government

2005
3 Kai Shing Street
Kowloon Bay

www.archsd.gov.hk

The new headquarters and depot was previously home to an air cargo terminal at Hong Kong's former airport. As a model of sustainable and adaptive reuse, the design boasts energy efficient devices such as integral solar panels, and binary ice storage.

In der neuen Zentrale samt Depot war zuvor ein Luftfracht-Terminal von Hong Kongs ehemaligem Flughafen untergebracht. Der Bau ist ein Musterbeispiel für anpassungsfähige und zukunftsträchtige Wiederverwendung, dessen Design energieeffiziente Anlagen integriert, wie etwa Solarzellen und Binäreisspeicher.

Le nouveau siège, dépôt compris, abritait auparavant un terminal de fret aérien de l'ancien aéroport de Hong Kong. C'est l'exemple type d'une réutilisation ingénieuse et porteuse d'avenir où la conception intègre des installations énergétiques efficaces, comme des cellules solaires et des équipements frigorifiques à glace binaire.

En la nueva central y depósito se ubicaba en el pasado la terminal de transporte aéreo de mercancías del antiguo aeropuerto de Hong Kong. Se trata de un claro ejemplo de la capacidad de adaptación y orientación hacia el futuro a la hora de reutilizar un espacio, cuyo diseño integra estructuras energéticas eficaces, como células solares y almacenadores binarios de hielo.

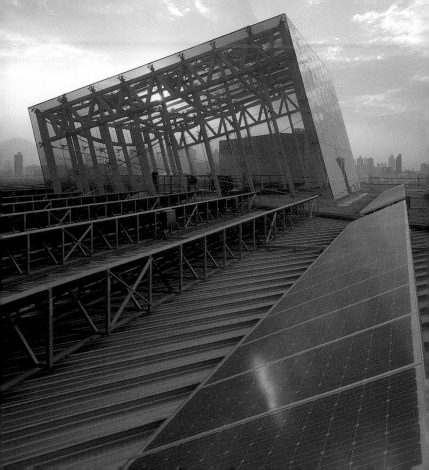

Hong Kong Science Park Phase 1

Architectural Services Department, HKSAR Government

2004
Science Park West Avenue
Shatin
New Territories

www.hkstp.org
www.archsd.gov.hk

Spanning 30 acres, the ten buildings are delineated into various zones within a park-like campus environment. The architectural focus is driven by the need for sophisticated infrastructural facilities and advanced technological and environmental systems to support scientific research.

Die zehn Gebäude liegen eingebettet in ein parkähnliches Areal von etwa zwölf Hektar, unterteilt in verschiedene Zonen. Im architektonischen Fokus steht der Bedarf an einer durchdachten Infrastruktur und modernen Technologie- sowie Umweltsystemen zur Unterstützung der wissenschaftlichen Arbeit.

Les dix bâtiments occupent une sorte de campus d'environ douze hectares divisé en différentes parties. Le projet architectural répond à la nécessité de recourir à une infrastructure étudiée et à des systèmes technologiques et écologiques modernes destinés à soutenir le travail scientifique.

Los diez edificios están inmersos en un área tipo parque de doce hectáreas y distribuidos por diferentes zonas. El foco de atención arquitectónico lo constituye la demanda de una infraestructura trabajada y tecnología moderna, así como los sistemas de medio ambiente concebidos para apoyar el trabajo de investigación.

46

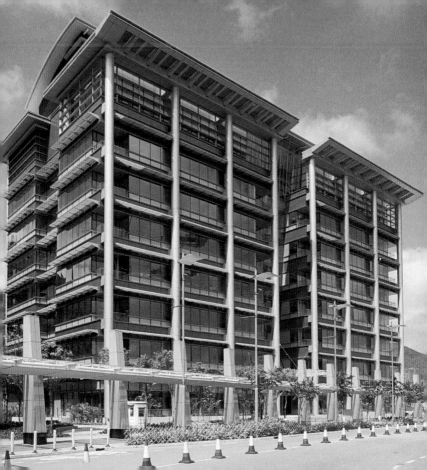

Hong Kong Science Park Phase 2

Leigh & Orange Ltd.
Meinhardt (C&S) Ltd. (SE)

2006-2007
Pak Shek Kok
Shatin
New Territories

www.leighorange.com
www.hkstp.org

Expanding the research and development complex by 26 acres, the glassy edifices are strung out along Tolo Harbor. The first two "energy towers" are under construction. Articulated by concrete and steel cladding, their elevations form bookends tilted towards the opposing highway.

Die verglasten Bauten vergrößern den Forschungs- und Gebäudekomplex um 10,5 Hektar und erstrecken sich entlang des Tolo Harbor. Die beiden ersten „Energietürme" befinden sich noch im Bau. Ihr beton- und stahlverkleidetes Äußeres ähnelt Buchstützen, die sich zum gegenüberliegenden Highway neigen.

Les immeubles vitrés agrandissent le complexe de recherche et de bâtiments de 10,5 hectares et s'étendent le long de Tolo Harbor. Les deux premières « tours énergétiques » sont encore en construction. Leur extérieur au revêtement de béton et d'acier ressemble à des serre-livres inclinés vers l'artère de passage opposée.

Los edificios acristalados amplían el complejo de investigación y desarrollo en 10,5 hectáreas, a lo largo del Tolo Harbor. Las dos primeras "torres energéticas" están aún en construcción. Su exterior de cemento y revestimiento de acero semeja a sujetalibros que parecen inclinarse hacia la autopista situada enfrente.

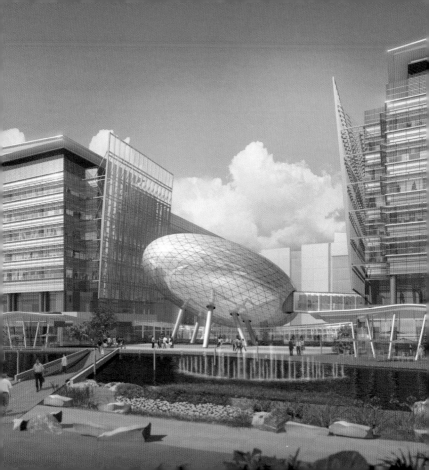

HSBC Innovation Centre

Diana Nutting, Debra Little, Michael Dolan, Dialogue Ltd.

2002
28/F HSBC Main Building
1 Queen's Road Central
Central

www.dialogueltd.com

Situated in the Sir Norman Foster designed headquarters the center is hosting seminars, exhibitions, and launching new business initiatives. A raised white platform defines these various zones with a transparent framework that compliments this architectural masterpiece.

Das HSBC Innovation Centre liegt in der von Sir Norman Foster gestalteten Zentrale. Es dient als Seminar- sowie Ausstellungsort und ist Startpunkt vieler Geschäftsinitiativen. Eine erhöhte weiße Plattform ist von einem transparenten Gerüst umgeben, das dieses architektonische Meisterwerk abrundet.

Le HSBC Innovation Centre se trouve au siège conçu par Sir Norman Foster. Il fait fonction de salle de séminaires et d'expositions et sert de point de départ à de multiples initiatives commerciales. Une plate-forme blanche surélevée est entourée d'un échafaudage transparent qui complète ce chef-d'œuvre architectural.

El HSBC Innovation Centre está ubicado en la central diseñada por Sir Norman Foster. Hace las funciones de sala de exposiciones y seminarios y constituye el punto de lanzamiento para numerosas iniciativas comerciales. Esta obra maestra arquitectónica se completa con una plataforma elevada de color blanco rodeada de un armazón transparente.

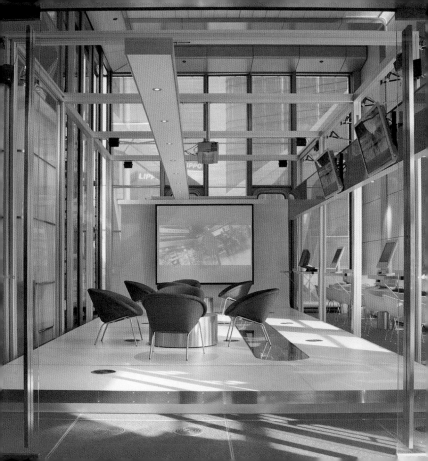

International Commerce Center

Kohn Pedersen Fox Associates PC
Ove Arup & Partners (HK) Ltd. (SE)

2008
Union Square
Kowloon

www.kpf.com

The 108-story tower is the center piece of a master plan for Union Square, a massive parcel of reclaimed land in West Kowloon. Its form rises from a splayed square base tapering towards the sky where it culminates in a luxury hotel and an observation deck on the 90th floor.

Der 108 Stockwerke hohe Turm bildet das Zentrum des Gesamtkonzepts für den Union Square, für welchen ein großes Stück Land in West Kowloon urbar gemacht wurde. Seine Form geht von einer rechteckigen Basis aus und verjüngt sich gen Himmel, im 90. Stockwerk sind ein Luxushotel und ein Beobachtungsdeck zu finden.

Ce gratte-ciel de 108 étages est la pièce maîtresse d'un projet général pour le Union Square, pour lequel une grande parcelle de terrain à l'ouest de Kowloon a été défrichée. Il est rectangulaire à la base et s'élève en se rétrécissant vers le ciel. Le 90ème étage abrite un hôtel de luxe et une plate-forme d'observation.

La torre de 108 pisos constituye el centro del concepto global ideado para la Union Square, para la que se desbrozó un basto terreno de West Kowloon. Su forma parte de una base rectangular que se estrecha hacia lo alto. En el piso 90 alberga un hotel de lujo y una terraza panorámica.

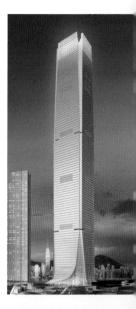

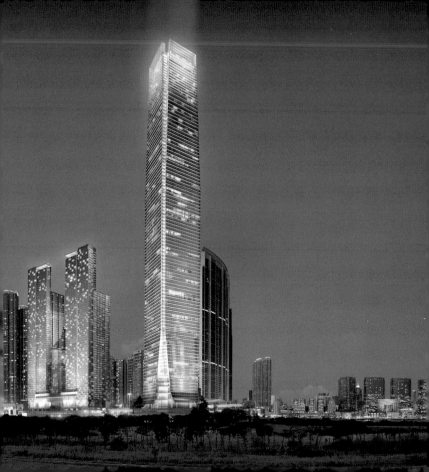

Mega iAdvantage Data Centre

Edge Design Institute Ltd.

2001
Chai Wan

www.edgedesign.com.hk

Asia's first data center set a benchmark for the typology with its rhythmic, alternating loops of materials and animated graphic surfaces. In the penthouse headquarters the space is generated from a matrix of lines that run into and across each other, blurring its boundaries.

Asiens wichtigstes Rechenzentrum hat mit seiner klaren Gestaltung, einer konstanten Materialpalette und animierten graphischen Flächen Maßstäbe gesetzt. In den Penthouse-Zentren wird der Raum von einer Matrix aus Linien erzeugt, die ineinander übergehen und sich kreuzen, so dass keine scharfen Grenzen erkennbar sind.

Par sa conception claire, sa palette de matériaux homogène et des surfaces graphiques animées, le plus important centre de calcul d'Asie fait figure de référence. Dans les centres penthouses, l'espace est généré par une matrice de lignes qui se croisent et se rejoignent, si bien que les frontières demeurent floues.

El más importante centro de procesamientos de datos de Asia marca pautas gracias a su concepción lúcida, una gama de materiales constantes y superficies gráficas animadas. En los centros Penthouse el espacio está constituido por una matriz de líneas cruzadas y entrelazadas entre sí desdibujando los límites.

MLC

Adam Mundy, MMoser Associates

2005
36th Floor, RBS Tower
Times Square
1 Matheson Street
Causeway Bay

www.mmoser.com
www.mlchk.com

Transparency and openness were the key goals in designing the offices for Australia's largest insurers. This is evident in the soaring atrium, which connects the three floors with its sculptural stairs and a large projection screen that stretches through the void.

Transparenz und Offenheit waren die zentralen Ziele für das Design der Büros von Australiens größtem Versicherungsunternehmen. Verwirklicht wurde dies durch das große Atrium, das die drei Ebenen mit skulpturgleichen Treppen verbindet, sowie durch die riesige Projektionsfläche, die sich durch den offenen Raum erstreckt.

La transparence et l'ouverture ont été les objectifs clés du design des bureaux de la plus grande compagnie d'assurances australienne. Objectifs réalisés grâce au grand atrium qui relie les trois niveaux au moyen d'escaliers sculpturaux et grâce à l'écran géant de projection qui s'étend sur tout l'espace.

A la hora de construir las oficinas de la mayor empresa de seguros australiana, se fijaron dos objetivos centrales de diseño: transparencia y apertura. Esto se hizo realidad a través de un amplio atrio que une los tres niveles con escaleras esculturales así como con las enormes superficies de proyección que se extienden por el espacio abierto.

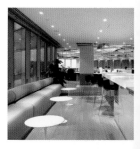

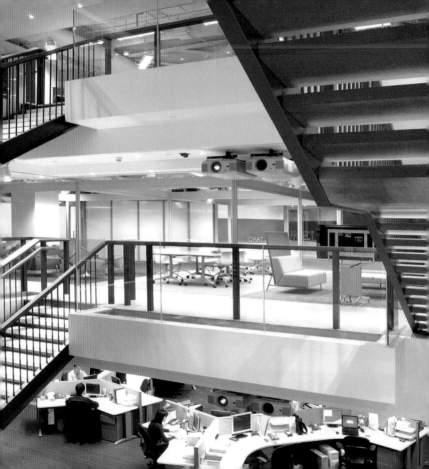

One Peking

Rocco Design Ltd.
WMKY Architects Engineers Ltd. (SE)

2003
1 Peking Road
Tsimshatsui
Kowloon

www.roccodesign.com.hk

The subtly raked tower gently bulges outwards then tapers towards its pinnacle. Advanced triple glazing, solar shading, and a shield of photovoltaic panels seamlessly finishing the top of the building result in a model of sustainable architecture.

Der leicht geneigte Turm ist nach außen gewölbt und verjüngt sich dann zur Spitze hin. Fortschrittliche Dreifachverglasung, Sonnenschutz und Photovoltaikplatten schließen den oberen Teil des Gebäudes ab, das ein Musterbeispiel für umweltbewusste Architektur ist.

Légèrement inclinée, la tour est bombée en son milieu et se rétrécit vers le sommet. Un triple vitrage à la pointe du progrès, des pare-soleil et des panneaux photovoltaïques complètent la partie supérieure du bâtiment, ce qui en fait un modèle d'architecture écologique.

Esta torre ligeramente inclinada y abombada se estrecha hasta la punta. La parte superior del edificio se conforma de acristalamientos triples, protección solar y planchas fotovoltaicas, lo que supone todo un ejemplo arquitectónico de conciencia ecológica.

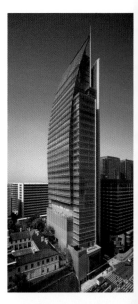

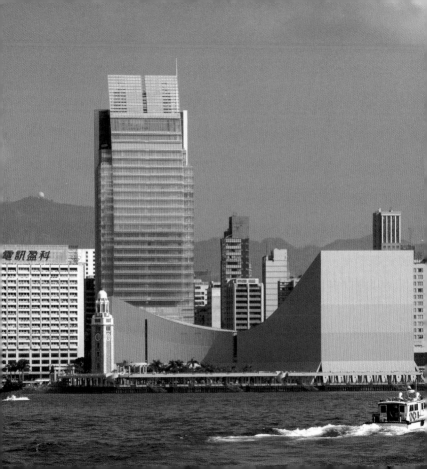

STAR TV Headquarters

marc & chantal design

2005
1 Harborfront
18 Tak Fung Street
Hunghom

www.marc-chantal.com

The corporate lobby and boardroom have been remodeled to radiate calm modernity. Comfort and timelessness take precedence over cool-tech projection walls and throbbing lights. A media garden creates a forest of trees across the glazed façade, each stem blooming with mini flat-screen monitors.

Lobby und Sitzungsraum verströmen nach dem Umbau eine Atmosphäre ruhiger Modernität. Komfort und zeitlose Gestaltung lassen Projektionswände und intensive Beleuchtung in den Hintergrund treten. Vor die verglaste Fassade ist ein Media-Garten aus Streben mit kleinen aufgesetzten Flachbildmonitoren gesetzt.

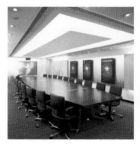

Une fois transformés, le foyer et la salle de réunion dégagent une atmosphère de sereine modernité. Le confort et le design intemporel font oublier les écrans de projection et les éclairages intensifs. Devant la façade vitrée, un jardin des médias a été installé, composé de tiges avec de petits moniteurs à écran plat.

Tras su reforma, el vestíbulo y las salas de reuniones emanan un ambiente de modernidad apacible. El diseño atemporal y de confort dejan la prioridad a las pantallas de proyección y la intensa iluminación. Delante de la fachada acristalada se ubica un jardín mediático de diagonales con pequeños monitores de pantalla plana.

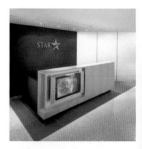

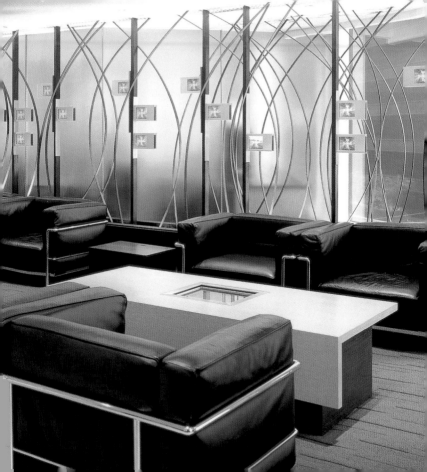

Swire Island East

Swire Properties Ltd.
Wong & Ouyang (HK) Ltd.

started in 1991
TaiKoo Place
Cityplaza

www.swireproperties.com
www.wongouyang.com

Hong Kong's largest commercial campus spans the business and retail centers of Cityplaza and TaiKoo Place. The latter comprises eight office towers linked by a transparent corridor containing gallery spaces, cafes and meeting areas.

Hong Kongs größtes Geschäftsareal umfasst die Unternehmens- und Handelszentren Cityplaza und TaiKoo Place. Zu letzterem gehören acht Bürotürme, die durch einen transparenten Gang miteinander verbunden sind, in dem Galerieflächen und Cafés sowie Sitzbereiche zu finden sind.

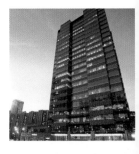

La plus grande zone d'activités de Hong Kong comprend les pôles d'entreprises et centres commerciaux Cityplaza et TaiKoo Place. Ce dernier compte huit tours de bureaux reliées entre elles par une allée transparente, qui abrite des galeries, des cafés et des espaces détente.

El espacio comercial más grande de Hong Kong comprende los centros de negocios Cityplaza y TaiKoo Place. A este último pertenecen ocho torres de oficinas, enlazadas entre sí a través de un pasillo transparente en el que se encuentran galerías y cafeterías así como espacios para sentarse.

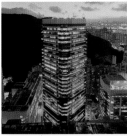

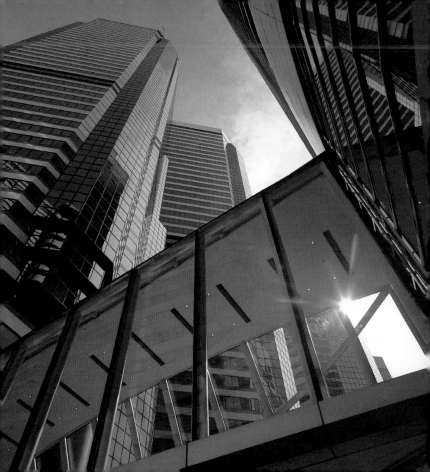

Three Pacific Place

Wong & Ouyang (HK) Ltd.
Ove Arup & Partners (HK) Ltd. (SE)

2004
1 Queen's Road East
Wanchai

www.wongouyang.com
www.threepacificplace.com.hk

The 38-story, tech-savvy tower forms an extended arm to the multi-use Pacific Place complex. The glassy curtain walled façade gives way to state-of-the-art working environments that combine advanced communication networks with uninterrupted 52,5 feet core-to-glass office space.

Der 38-stöckige, hochtechnologische Turm bildet die Erweiterung des Mehrzweckkomplexes Pacific Place. Die gläsernen Vorhangfassaden ermöglichen eine optimale Arbeitsumgebung, die einen modernen Kommunikationsbereich mit einem 16 Meter breiten, frei nutzbaren Bürobereich ohne Stützen kombiniert.

Cette tour de 38 étages à haute technologie constitue l'extension du complexe polyvalent Pacific Place. Les façades-rideaux vitrées créent un environnement de travail idéal qui combine un système de communication moderne avec une zone de bureaux modulable, sans piliers, de 16 mètres de large.

La torre de alta tecnología con 38 plantas constituye una ampliación del complejo multifuncional de Pacific Place. Las fachadas de cortina acristaladas proporcionan un entorno de trabajo óptimo, que combina una sistema de comunicación moderna con una zona abierta de oficinas de 16 metros de anchura sin apoyos.

Two IFC

Cesar Pelli & Associates Inc.
Ove Arup & Partners (HK) Ltd. (SE)

2003
1 Harbor View Street
Central

www.cesar-pelli.com
www.ifc.com.hk

Hong Kong's tallest tower, standing at 1378 feet, dominates the city skyline. It dwarfs its neighbors with a soaring, gently tapering façade that is cut inwards at intervals until it reaches the 88th floor where the skin dissolves into rows of clasping fingers, reaching for the sky.

Hong Kongs höchster Turm misst 415 Meter und dominiert die Skyline der Stadt. Die sich verjüngende Fassade weist bis zum 88. Stock regelmäßige Einschnitte auf, dann mündet sie scheinbar in einer Reihe greifender Finger, die sich nach dem Himmel ausstrecken. Neben diesem Riesen wirken seine Nachbarn gar winzig.

Le plus haut gratte-ciel de Hong Kong fait 415 mètres, dominant toute la silhouette urbaine. Sa façade se rétrécit régulièrement par encoches jusqu'au 88ème étage, débouchant apparemment sur une rangée de doigts préhenseurs, dressés vers le ciel. A côté de ce géant, ses voisins ressemblent à des nains.

La torre más alta de Hong Kong alcanza los 415 metros y domina las vistas de la ciudad. La fachada se estrecha en cortes regulares estructurados hasta el piso 88 y a partir de ahí desemboca en una aparente pezuña pretendiendo tocar el cielo. Frente a semejante coloso los edificios vecinos parecen minúsculos.

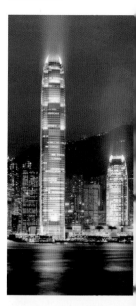

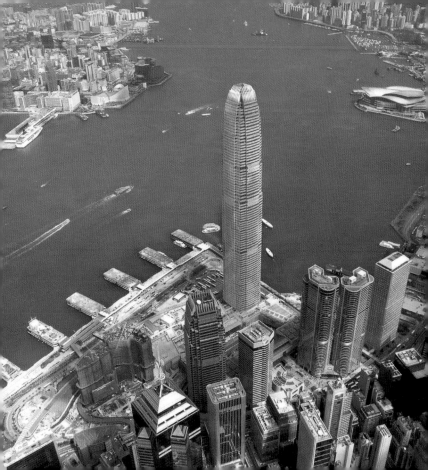

Broadway Cinematheque

Edge Design Institute Ltd.

1997
3 Public Square Street
Yau Ma Tei
Kowloon

www.cinema.com.hk
www.edgedesign.com.hk

Cinema attracts a wide audience to the remodeled venue, alongside a film art library, cafe, shop, and seminar lounge. Inspired by textures from the neighborhood, spaces have an ad-hoc, "unfinished" character, through an inventive use of materials and lighting.

Das Kino lockt ein breites Publikum in das umgebaute Gebäude, das zudem eine Filmkunst-Bibliothek, ein Café sowie eine Seminarlounge bietet. Inspiriert durch das Gefüge der Nachbarschaft haben die Räumlichkeiten einen gewollt „unfertigen" Charakter, erzeugt durch den innovativen Einsatz von Materialien und Licht.

Le cinéma attire un large public dans ce bâtiment remodelé qui abrite également une cinémathèque, un café et une salle de séminaires. A l'instar de la structure du voisinage, les locaux ont un air délibérément « inachevé », engendré par l'emploi innovant des matériaux et de la lumière.

Todo tipo de público se siente atraído por el cine de este edificio reestructurado, que además cuenta con una biblioteca sobre el arte cinematográfico, una cafetería y una sala para seminarios. Los espacios han sido inspirados en las estructuras colindantes y transmiten un carácter "inacabado", concebido a través del juego entre materiales y luz.

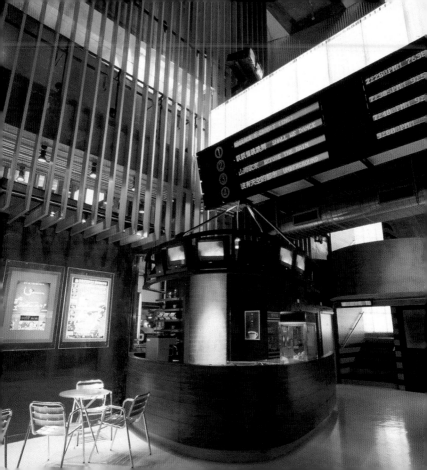

HKPA Children & Youth Service Centre

Laurence Liauw, Tony Leung, Design Architects

2004
2F, 53 Tanner Road
North Point

www.sd.polyu.edu.hk
www.urb.com.hk
www.hkpa.hk

The center provides multiple services to a spectrum of socially vulnerable children and teenagers. The age range presented a challenge in terms of integrating all the users, and emphasis lies in the freedom to choose space and how to use it.

Das Dienstleistungszentrum bietet zahlreiche Einrichtungen für Kinder und Jugendliche. Die großen Altersunterschiede stellten eine Herausforderung dar, da alle Nutzer integriert werden sollten. Deshalb bietet das Design die Möglichkeit, den Raum zu verschiedenen Zeiten auf unterschiedliche Weise zu nutzen.

Ce centre de services sociaux propose de nombreux équipements pour enfants et adolescents. Le défi était d'intégrer tous les utilisateurs, malgré les grandes différences d'âge entre eux. C'est pourquoi le concept offre la possibilité d'exploiter l'espace de différentes manières à différents moments.

Este centro de servicios cuenta con cantidad de instalaciones para niños y jóvenes. El reto es sin duda la diferencia de edades, puesto que se trata de incluir a todos los usuarios. Por ello se ha optado por un diseño que ofrece la posibilidad de emplear el espacio en diversos momentos de formas diferentes.

HKU, Kadoorie Biological Sciences Building

Leigh & Orange Ltd.
Ove Arup & Partners (HK) Ltd. (SE)

2002
Hong Kong University Campus
Pokfulam

www.leighorange.com
www.arch.hku.hk

Located on the University of Hong Kong campus, the building of teaching and research laboratories is distinguished by its inherent sustainability, flexibility and functionality. The entire façade is a double skin arrangement of glazed screens to produce natural ventilation and reduce solar glare.

Auf dem Campus der Universität von Hong Kong steht dieses Lehr- und Forschungsgebäude, das sich durch Nachhaltigkeit, Flexibilität und Funktionalität auszeichnet. Die gesamte Fassade ist eine doppelschalige Glaskonstruktion, welche natürliche Belüftung gewährleistet und die Sonneneinstrahlung reduziert.

Situé sur le campus de l'université de Hong Kong, ce bâtiment destiné à l'enseignement et aux laboratoires de recherche se définit par la durabilité, la flexibilité et la fonctionnalité. L'ensemble de la façade est une construction à double coque de verre qui assure une aération naturelle et réduit le rayonnement du soleil.

En el campus de la universidad de Hong Kong se levanta este edificio de investigación y aprendizaje caracterizado por su persistencia, flexibilidad y carácter funcional. La fachada completa es una composición de cristal doble que proporciona ventilación natural y reduce la radiación solar.

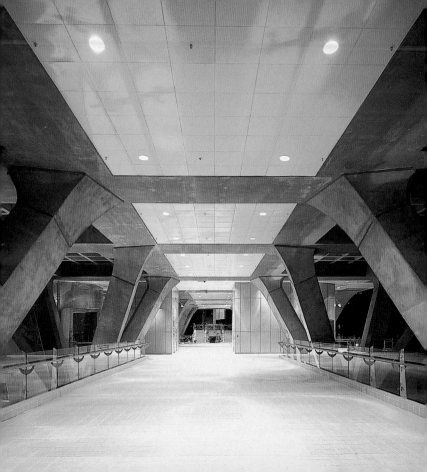

Hong Kong Arts Centre Atrium Renovation

Edge Design Institute Ltd.

2000
2 Harbor Road
Wanchai

www.hkac.org.hk
www.edgedesign.com.hk

The four-story atrium is a spatial organizer, connecting various foyers that link into performance theaters and exhibition galleries. Previously underutilized, the renovation focused on inserting flexible activities, such as cafes and shops, without disturbing the architecture.

Das vierstöckige Atrium organisiert das Raumgefüge durch verschiedene verbundene Foyers, die zu Theatern und Ausstellungsräumen führen. Da das Gebäude nicht ausgelastet war, konzentrierte sich die Renovierung darauf, flexible Einrichtungen wie Cafés und Shops zu integrieren, ohne die Architektur zu stören.

Cet atrium de quatre étages a pour fonction d'articuler l'espace par l'intermédiaire de différents foyers conduisant à des salles de théâtre et d'expositions. Comme le bâtiment était sous-exploité, la rénovation s'est concentrée sur l'intégration d'installations adaptables telles que cafés et boutiques sans gêner l'architecture.

Este atrio de cuatro plantas organiza la estructura del recinto a través de diversos vestíbulos unidos que conducen a teatros y salas de exposiciones. Debido a que no se daba uso al edificio completo, los trabajos de renovación se concentran en integrar instalaciones flexibles, como cafeterías y tiendas, sin dañar la arquitectura existente.

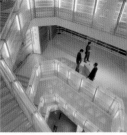

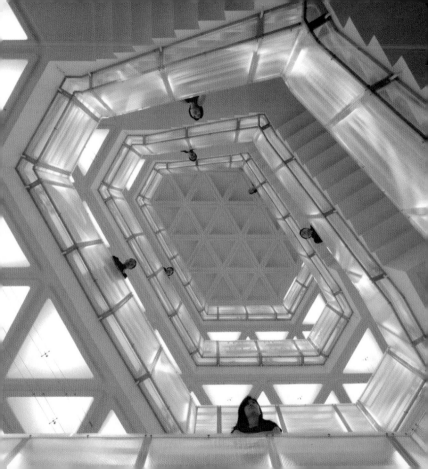

The Hong Kong Museum of Coastal Defence

Architectural Services Department, HKSAR Government

1999
175 Tung Hei Road
Shau Kei Wan

www.lcsd.gov.hk/CE/Museum/
Coastal/en/index.php
www.archsd.gov.hk

Constructed on the former Lei Yue Mun Fort, which suffered heavy bombardment during World War II, its elevated, headland position offers an ideal vantage point at the gateway to the harbor. The architecture is restrained with a lightweight tensile membrane enclosing the historic structure.

Auf dem Gelände des ehemaligen Lei Yue Mun Forts, das im Zweiten Weltkrieg stark beschädigt wurde, ist dieses Museum errichtet. Aufgrund seiner erhöhten Lage auf einem Kap hat man von hier aus eine gute Sicht auf den Hafen. Die Architektur ist zurückhaltend, eine leichte Membran umschließt die historische Struktur.

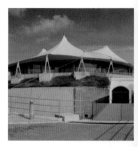

Sur le terrain de l'ancien Fort Lei Yue Mun, qui fut fortement endommagé pendant la deuxième guerre mondiale, s'est construit ce musée. Situé en surplomb sur un cap, il offre une excellente vue sur le port. L'architecture est discrète, une membrane légère entoure la structure d'origine.

El museo ha sido ubicado en el recinto del antiguo Lei Yue Mun Fort, que sufrió enormes daños durante la Segunda Guerra Mundial. Su situación elevada sobre el cabo le dota de buenas vistas al puerto. La arquitectura es más bien discreta y se caracteriza por una ligera carpa tensada que recubre la estructura histórica.

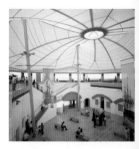

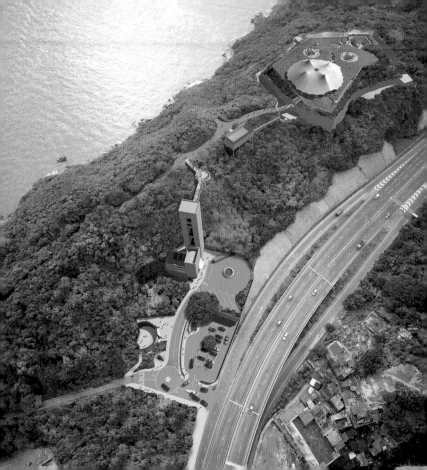

Hong Kong Wetland Park

Architectural Services Department, HKSAR Government

2005
Wetland Park Road
Tin Shui Wai

www.wetlandpark.com
www.archsd.gov.hk

Integrated with the natural setting of a 151-acre park, the buildings are sensitively designed with landscaped roofs, and a system of shading. The visitor center includes three major galleries, and an extensive lawn leads to three discreet bird hides.

In die natürliche Umgebung eines 61 Hektar großen Parks sind diese Gebäude integriert. Sie wurden umweltsensibel gestaltet und weisen begrünte Dächer und ein durchdachtes System zur Beschattung auf. Im Besucherzentrum gibt es drei wichtige Galerien und eine große Rasenfläche, die zu drei Aussichtspunkten führt.

Ces bâtiments sont intégrés dans le cadre naturel d'un parc de 61 hectares. Ils ont été conçus dans le respect de l'environnement et sont dotés de toitures végétalisées et d'un système d'ombrage sophistiqué. Dans le centre d'accueil des visiteurs il y a trois galeries importantes et une grande pelouse menant à trois points de vue.

Los edificios están integrados dentro del entorno natural de un gran parque de 61 hectáreas. Se han concebido con principios ecológicos y cuentan con tejados cubiertos de césped y un estudiado sistema para proporcionar sombra. En el centro de visitantes se ubican tres galerías importantes y una gran superficie de césped que conduce a tres puntos panorámicos.

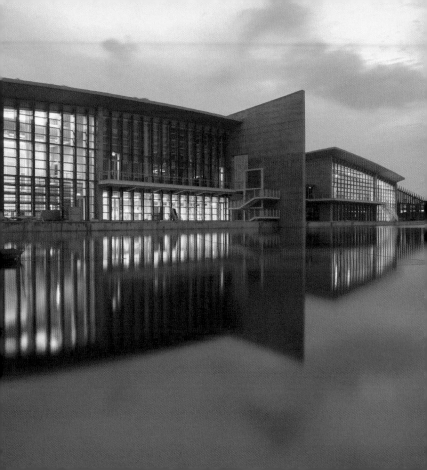

Kingston International School

Denise W.M. Kwong, Paul Collins, Frankie M.T. Lui, Kwong & Associates Ltd.

2001
113 Waterloo Road
Kowloon Tong

www.kingston.edu.hk

The architecture stems from the school's emphasis on creativity. Surface pattern, color and a dynamic composition of glazing provide the building's memorable identity whilst environmental concerns, such as natural ventilation and managed-resource timbers, take priority.

Die Architektur zeugt von dem kreativen Schwerpunkt der Schule. Oberflächenstruktur, Farbe sowie eine dynamische Komposition bei der Verglasung verleihen dem Gebäude eine außergewöhnliche Identität. Dabei haben Umweltbelange wie eine natürliche Belüftung und ressourcenfreundliche Hölzer Priorität.

L'architecture témoigne de l'accent mis par cette école sur la créativité. La structure de surface, les couleurs ainsi que la composition dynamique du vitrage confèrent au bâtiment une identité particulière. Priorité a été donnée aux préoccupations écologiques, comme l'aération naturelle et les bois de construction renouvelables.

La arquitectura es reflejo de la base creativa de la escuela. Tanto las estructuras de las superficies como los colores y la composición dinámica que desprende del acristalado otorgan al edificio una identidad atípica. En la construcción el respeto al medio ambiente ha sido una prioridad que se evidencia en el sistema de ventilación natural, y la elección de maderas conforme a los recursos naturales.

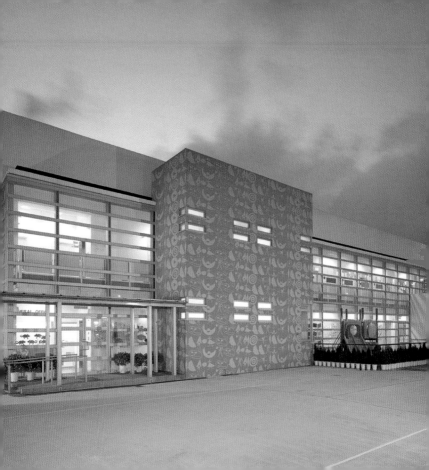

Fanling Open Space

Architectural Services Department, HKSAR Government

2003
Luen Wo Hui
Fanling

www.archsd.gov.hk

The project comprises a central lawn, garden, seating area, and a service building, delicately woven into less than 2,5 acres. In contrast to the colossal residential towers around it, the volumes are dissected into planes corresponding to the horizontality of the various landscapes.

Das Projekt umfasst eine zentrale Rasenfläche, Garten, Sitzbereich und ein Service-Gebäude, alles auf weniger als einem Hektar gekonnt miteinander verwoben. Im Gegensatz zu den riesigen Wohnblocks rundherum wurden hier einzelne, niedrige Bauten errichtet, die sich in die Landschaft einfügen.

Le projet comprend une pelouse au centre, un jardin, des bancs et un bâtiment public, le tout sur moins d'un hectare, harmonieusement combiné. Par opposition aux immeubles géants des alentours, on a privilégié ici des bâtiments séparés, peu élevés, qui s'intègrent dans le paysage.

El proyecto de edificación comprende un recinto verde central, jardín, espacios para sentarse y edificios para servicios. Todo ello entrelazado en una superficie de menos de una hectárea. Creando contraste con los gigantescos edificios de viviendas que le rodean, aquí se ha optado por construcciones de baja altura que se insertan en el paisaje.

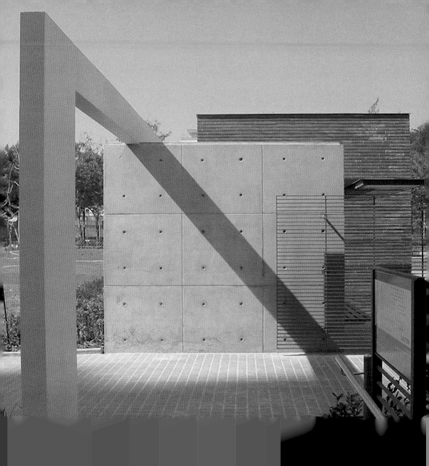

Hong Kong Police Headquarters

Architectural Services Department, HKSAR Government

2005
1 Arsenal Street
Wanchai

www.archsd.gov.hk

The complex expresses transparency, clarity of organization, and environmental conservation. Visually, it is broken down into three major components, anchored by a 42-story tower. Identification and signage are perfectly integrated to ensure user-friendly ease of access and communication.

Dieser Komplex vereint Transparenz, eine klare Organisation und umweltbewusste Gestaltung. Er ist in drei Hauptelemente gegliedert; das Zentrum bildet ein 42-stöckiger Turm. Identifikationssystem und Beschilderung wurden optimal integriert, so dass ein nutzerfreundlicher Zugang und problemlose Orientierung gesichert sind.

Ce complexe conjugue transparence, clarté d'organisation et conception attentive à l'environnement. Il s'articule en trois éléments principaux autour d'une tour de 42 étages. Le système d'identification et la signalisation ont été parfaitement intégrés, si bien que les utilisateurs peuvent y accéder confortablement et s'orienter sans problème.

El complejo aúna transparencia, organización definida y un diseño respetuoso con el medio ambiente. Está fragmentado en tres elementos principales, cuyo centro lo constituye una torre de 42 plantas. Los sistemas de identificación y la señalización han sido integrados de forma óptima, con el fin de asegurar a los usuarios un acceso cómodo y una fácil orientación.

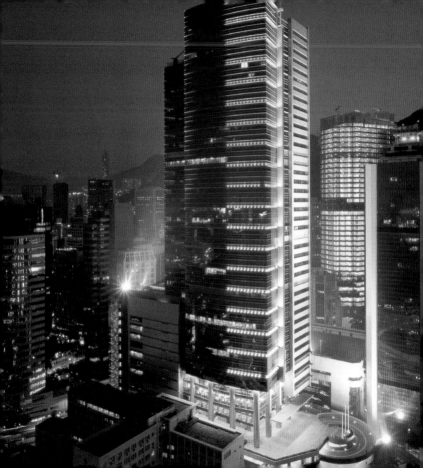

Hong Kong Station & Development

Rocco Design Ltd.
Ove Arup & Partners (HK) Ltd. (SE)

2005
Central

www.roccodesign.com.hk

Linking high-rise towers, landscaped open space and a retail podium, these cleverly orchestrated series of volumes primarily act as an interchange between various transportation networks. It is also a nucleus of urban integration, like the final piece of a jigsaw puzzle.

Diese geschickt angeordnete Ansammlung von Gebäuden verbindet Hochhäuser, eine offene Grünfläche und Geschäfte miteinander und dient in erster Linie zum Umsteigen zwischen verschiedenen Verkehrsmitteln. Außerdem ist der Komplex Sinnbild urbaner Integration und fügt sich wie ein letztes Puzzlestück in das Gesamtbild ein.

Ce groupe de bâtiments savamment disposés fait le lien entre des gratte-ciel, un espace paysagé et des magasins et constitue avant tout une plate-forme pour passer d'un moyen de transport à un autre. Ce complexe est le symbole de l'intégration urbaine et s'agence dans cet ensemble comme la dernière pièce d'un puzzle.

Esta agrupación de construcciones hábilmente dispuesta vincula edificios altos, un espacio verde abierto, una serie de comercios y sirve principalmente de punto de trasbordo entre diversos medios de transporte. El complejo es además símbolo de la integración urbana y se ajusta al conjunto como si de la última pieza de un puzzle se tratase.

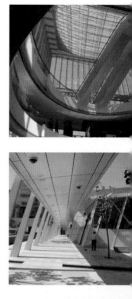

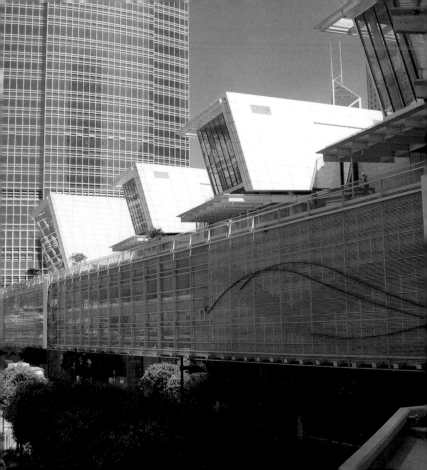

Sai Kung Waterfront

Architectural Services Department, HKSAR Government

2004
Wai Man Road
Sai Kung Pier
Sai Kung

www.archsd.gov.hk

The popular promenade and alfresco dining spot has been enhanced by a new visitor center, the upgrade of an adjoining park and the addition of an elegant glass shelter on the pier. Stronger linkages between transport termini and the Tin Hau Temple create a more user-friendly environment.

Die Promenade, beliebt aufgrund vieler Möglichkeiten zum Speisen unter freiem Himmel, wurde durch ein neues Besucherzentrum, einen angrenzenden Park und eine elegante Glasüberdachung des Piers erweitert. Bessere Verbindungen zwischen den Haltestellen und dem Tin-Hau-Tempel gestalten die Umgebung besucherfreundlicher.

La promenade, un endroit très populaire où l'on peut dîner en plein air, a été embellie par un nouveau centre d'accueil des visiteurs, un parc attenant et une marquise en verre sur le pont. De meilleures correspondances entre les arrêts des transports publics et le temple Tin Hau créent un environnement plus convivial.

El paseo, famoso por su amplia oferta para comer al aire libre, fue ampliado con un centro de visitantes, un parque adjunto y un elegante sotechado de cristal sobre el muelle. La ampliación de conexiones entre las paradas de transporte público y el templo Tin Hau hacen que el entorno sea aún más atractivo y accesible para los visitantes.

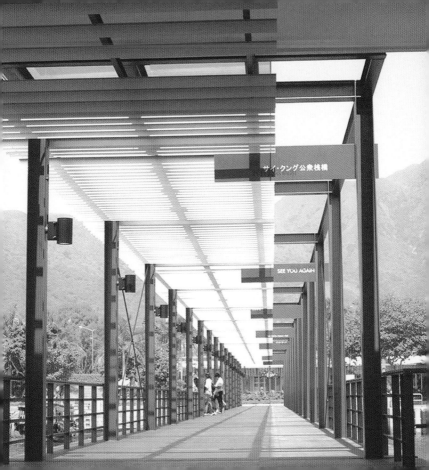

Stonecutters Bridge

DISSING+WEITLING
Flint + Neill Partnership
Halcrow Group Ltd.
SMEDI (Shanghai Municipial Engineering Design Institute)

2008
Rambler Channel
Stonecutters Island - Tsing Yi Island

www.dw.dk
www.roadtraffic-technology.com/
projects/stonecutters/

When completed, it will be the longest cable-stayed bridge in the world with a span of 3339 feet and an overall length of 5236 feet. Straddling the Rambler Channel at the entrance to the busy Kwai Chung Container Port, it will form part of Route 9, linking Tsing Yi and Cheung Sha Wan.

Wenn sie vollendet ist, wird sie mit einer Spannweite von etwa 1020 Metern und einer Gesamtlänge von knapp 1600 Metern die längste Schrägseilbrücke der Welt sein. Sie überspannt den Rambler Channel am Eingang zum geschäftigen Kwai-Chung-Containerhafen und ist Teil der Route 9, die Tsing Yi und Cheung Sha Wan miteinander verbindet.

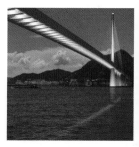

Quand il sera achevé, ce pont, avec sa portée de presque 1020 mètres et sa longueur totale de quelque 1600 mètres, sera le plus long pont haubané du monde. Il enjambe à l'entrée le Rambler Channel et le port pour conteneurs très actif de Kwai Chung et fait partie de la Route 9 reliant Tsing Yi à Cheung Sha Wan.

A su término este puente se habrá convertido en el puente colgante más grande del mundo, con una envergadura de 1020 metros y 1600 de longitud total. Atraviesa el Rambler Channel hasta el agitado puerto de containers Kwai Chung y es parte de la Route 9, que enlaza Tsing Yi con Cheung Sha Wan.

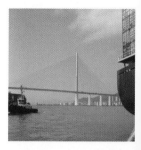

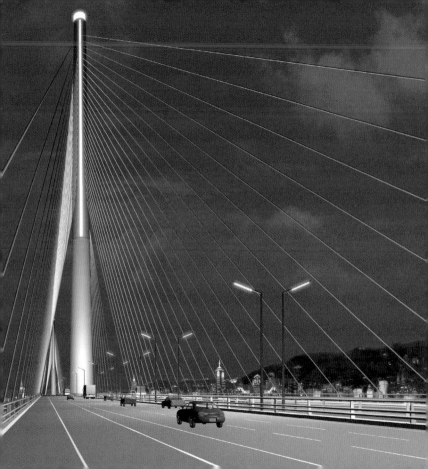

Terminal 2 / SkyPlaza

Skidmore, Owings & Merrill LLP
Ove Arup & Partners (HK) Ltd. (SE)
Mott Connell (SE)
Aedas (SE)

2006
Hong Kong International Airport
Lantau Island

www.som.com
www.hongkongairport.com/eng/
aboutus/development.html

Currently under construction, the multi-use development will expand the existing airport facilities by 1.6 million square feet and accommodate ferry services, transport interchanges, two office buildings and the SkyPlaza retail, dining and entertainment center.

Terminal 2 befindet sich gerade im Bau. Die Einrichtungen des Flughafens werden durch das neue Multifunktionsgebäude um 15 Hektar erweitert. Es wird auch Fährunternehmen, Transportbetriebe, zwei Bürogebäude sowie den SkyPlaza-Shopping-Bereich, Restaurants und ein Freizeitzentrum beherbergen.

Le Terminal 2 est actuellement en construction. Les installations de l'aéroport s'agrandiront de 15 hectares avec le nouveau bâtiment polyvalent. Il abritera aussi des compagnies de ferry, des transporteurs, deux immeubles de bureaux ainsi que le centre commercial SkyPlaza, des restaurants et un complexe de loisirs.

La Terminal 2 se encuentra actualmente en construcción. Las instalaciones del aeropuerto van a ser ampliadas en unas 15 hectáreas con un nuevo edificio multifuncional. El espacio albergará además empresas de líneas de ferry y otros transportes, así como dos edificios de oficinas, el espacio comercial SkyPlaza, restaurantes y un centro de ocio.

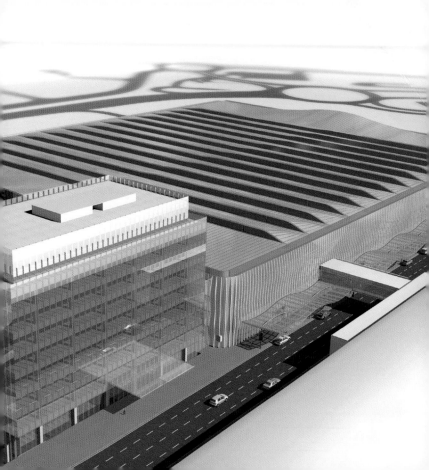

West Kowloon Promenade

Architectural Services Department, HKSAR Government

2005
Austin Road West
Kowloon

www.archsd.gov.hk

Comprising five acres of public space stretching along a finger of reclaimed land, the 1312 foot harbor-front walk is Hong Kong's longest. A "dragon" of 70 triangular light towers made from corrugated plastic are placed along the timber promenade, designed with the help of local artists.

Die 400 Meter lange Hafenpromenade auf einer zwei Hektar großen, erschlossenen Landzunge ist die längste Hong Kongs. Mithilfe lokaler Künstler wurde auf der hölzernen Promenade ein „Drachen" aus 70 dreieckigen Lichtsäulen, die aus gewelltem Kunststoff bestehen, installiert.

Sur 400 mètres, cette promenade en bordure de mer, aménagée sur une langue de terre de deux hectares, est la plus longue de Hong Kong. A l'aide d'artistes locaux, un « dragon » composé de 70 lampadaires triangulaires en plastique ondulé, a été installé sur le ponton de bois.

El paseo marítimo de 400 metros de longitud descansa sobre una lengua de tierra urbanizada de dos hectáreas y es el mayor de todo Hong Kong. Gracias a la contribución de artistas locales sobre el paseo de madera se erigió un "dragón" compuesto por 70 columnas de luz triangulares hechas en plástico ondulado.

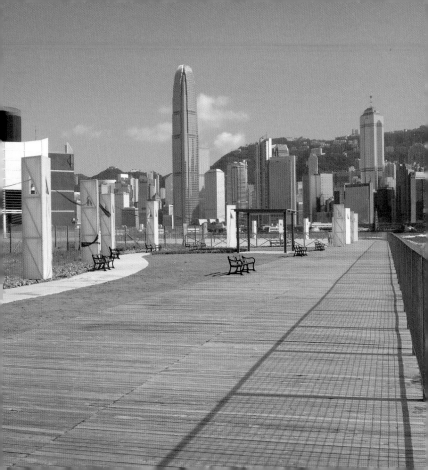

to stay . hotels

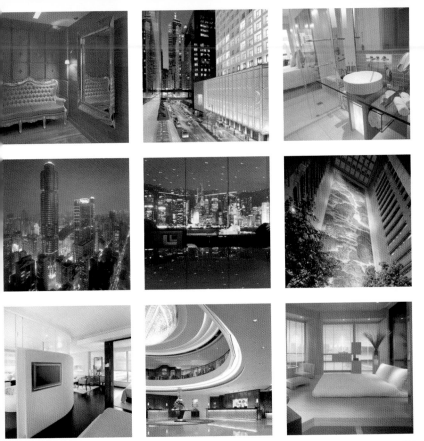

97

Grand Hyatt Plateau

John Morford, Morford & Company Ltd.

2004
Grand Hyatt Hong Kong
1 Harbor Road
Wanchai

www.plateau.com.hk

The self-contained sanctuary combines residential spa rooms, state-of-the-art fitness studios, and an elevated landscape encompassing a courtyard lounge, pool, athletic garden, function room and alfresco dining. Spa guestrooms are lined in sassafras timber and furnished with custom-designed futon beds.

Die eigenständige Zufluchtsstätte kombiniert Spa-Räume und moderne Fitness-Studios mit einem höher gelegenen Areal, wo sich eine Hof-Lounge, ein Pool, ein Sportgarten, ein Veranstaltungssaal und ein Restaurant im Freien befinden. Die Zimmer mit Spa sind in Sassafrasholz gehalten und mit speziell angefertigten Futons ausgestattet.

Ce refuge un peu à l'écart comprend des salles de spa et des studios de fitness modernes ainsi qu'un terre-plein où sont aménagés un salon en extérieur, une piscine, un jardin d'athlétisme, une salle de manifestations et un restaurant en plein air. Les chambres avec spa sont en bois de sassafras et meublées de futons fabriqués spécialement.

Este refugio de placer combina salas spa y modernos gimnasios con un área elevada que integra un patio lounge, piscina, jardín deportivo y salón de eventos, así como restaurante al aire libre. Las habitaciones con spa están revestidas de madera de sasafrás y diseñadas con futones hechos a medida.

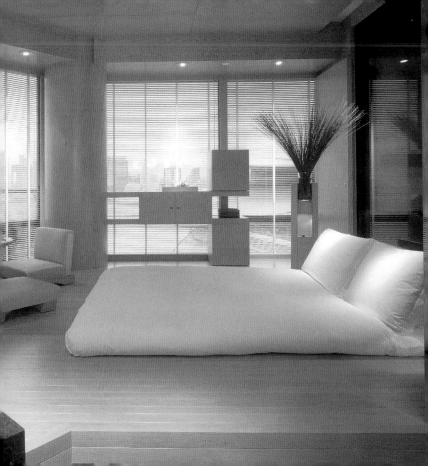

InterContinental Hong Kong

Lim · Teo + Wilkes Design Works
Chhada Siembieda Australia

2005
18 Salisbury Road
Kowloon

www.hongkong-ic.intercontinental.com
www.ltwdesignworks.com
www.chhada.com

The contemporary splendor of the lobby lounge has been revitalized to mirror the integrity of the architecture and accentuate the unrivaled harbor views. In the newly renovated guestrooms, streamlined modernity and technology are blended with Asian influences in art and accessories.

Die zeitgenössische Pracht des Foyers wurde modernisiert, um die Geschlossenheit der Architektur zu unterstreichen und den unvergleichlichen Hafenblick adäquat zur Geltung zu bringen. In den frisch renovierten Gästezimmern sind elegante Modernität und Technologie mit Kunsteinflüssen und Accessoires aus Asien vereint.

Le hall d'entrée, d'une splendeur très contemporaine, a été modernisé pour souligner l'intégrité de cette architecture et pour mettre parfaitement en valeur l'incomparable vue sur le port. Dans les chambres fraîchement rénovées, la technologie, associée à une élégante modernité, se mêle à des influences asiatiques dans la décoration artistique et les accessoires.

El esplendor contemporáneo del vestíbulo ha sido modernizado con el fin de acentuar el aspecto cerrado de la arquitectura y poner de relieve adecuadamente las incomparables vistas al puerto. Las habitaciones han sido reformadas dando así frescor y emanan una modernidad dotada de elegancia y tecnología, en comunión con influencias artísticas y accesorios asiáticos.

100

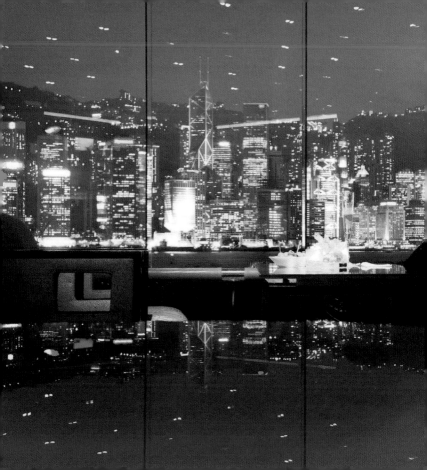

JIA Hong Kong

Philippe Starck

2004
1-5 Irving Street
Causeway Bay

www.philippe-starck.com
www.jiahongkong.com

The boutique hotel apartments are cozily domestic, cocooned in white gauzy drapes and compressing all one needs for living in studio, one-bedroom, or two-bedroom penthouse spaces. Color and material add drama through their constrained use.

Die Appartements des Boutique-Hotels sind gemütlich mit weißen Gaze-Vorhängen ausgestattet und enthalten alles, was man für den Aufenthalt in einem Studio oder in Ein- bis Zwei-Zimmer-Penthouseeinheiten benötigt. Der unaufdringliche Einsatz von Farben und Materialien verleiht ihnen einen besonderen Charme.

Les appartements de cet hôtel-boutique, très confortables avec leurs rideaux de gaze blanche, contiennent tout ce dont on peut avoir besoin pour séjourner dans un studio ou un penthouse de une ou deux pièces. La mise en œuvre discrète des couleurs et des matériaux leur confère un charme particulier.

Los apartamentos de este Boutique-Hotel con acogedoras cortinas de gasa blanca, disponen de todo lo necesario para una estancia en un estudio o en un penthouse de dos habitaciones. Colores y materiales sosegados acentúan el encanto del lugar.

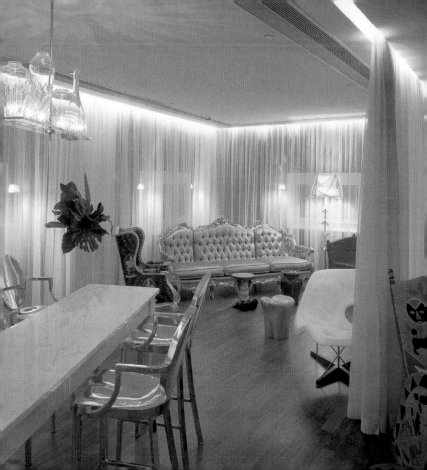

Langham Place Hotel
Mongkok, Hong Kong

Kevin K.L. Pang
Donald Tsang (SE)

2004
555 Shanghai Street
Mongkok
Kowloon

www.langhamhotels.com/langham-place/hongkong

Rising 42 stories, the curvilinear form of the tower strikes a distinctive profile above the street level revelry of Mongkok. The 665-room, five-star hotel is sumptuously contemporary, hitting exactly the right note for a downtown oasis that's a perfect haven from the city heat.

Der geschwungene 42-stöckige Wolkenkratzer hat ein unverwechselbares Profil und ragt aus dem Straßengetümmel von Mongkok heraus. Das Fünf-Sterne-Hotel mit 665 Zimmern ist eine zeitgemäße Innenstadt-Oase inmitten des hektischen Stadtlebens.

Reconnaissable entre tous, le profil de ce gratte-ciel effilé de 42 étages, se dresse au-dessus du brouhaha des rues de Mongkok. Cet hôtel cinq étoiles qui comprend 665 chambres est le havre de paix contemporain du centre ville au cœur des activités fiévreuses de la cité.

El rascacielos ondulado de 42 plantas se levanta entre la agitación callejera de Mongkok con su perfil inconfundible. EL hotel de cinco estrellas alberga 665 habitaciones y conforma un oasis contemporáneo en el centro de una ciudad en pleno ajetreo.

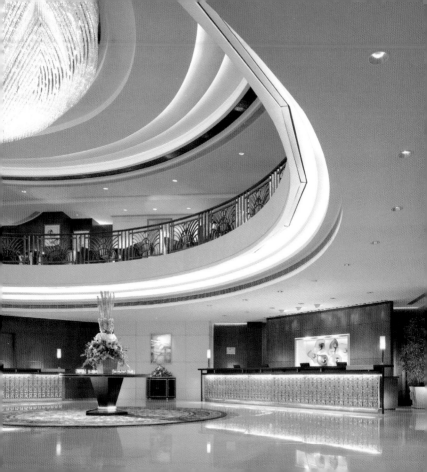

Le Meridien Cyberport

Arquitectonica
Wilson & Associates
LRF Designers Ltd.

2004
100 Cyberport Road
Pokfulam

www.arquitectonica.com
www.lemeridien.com

Setting a style between rural relaxation and city-slick glamour, the hotel brings the best of both worlds to executive travelers and leisure seekers. Flanking the waterfront edge of Hong Kong's information technology hub, Cyberport, the guestrooms are uncompromisingly tech-smart.

Mit einer Mischung aus ländlicher Entspannung und städtischem Glamour bietet das Hotel das Beste beider Welten für Geschäftsreisende und Urlauber. An der Uferseite des Cyberport gelegen, Hong Kongs Zentrum für Informationstechnologie, weisen auch die Zimmer alle technischen Raffinessen auf.

Avec un mélange de détente champêtre et de glamour urbain, l'hôtel procure le meilleur des deux mondes aux hommes d'affaires et aux vacanciers. Sur la rive du Cyberport, le centre des technologies de l'information de Hong Kong, ses chambres sont dotées elles aussi de tout le raffinement technique possible.

Con una combinación perfecta del relax del campo y el glamour urbano el hotel ofrece lo mejor de ambos mundos para huéspedes en viaje de negocios o de vacaciones: Ubicado a orillas del Cyberport, centro para tecnología de la información de Hong Kong, el hotel integra también en sus habitaciones todo tipo de refinamiento técnico.

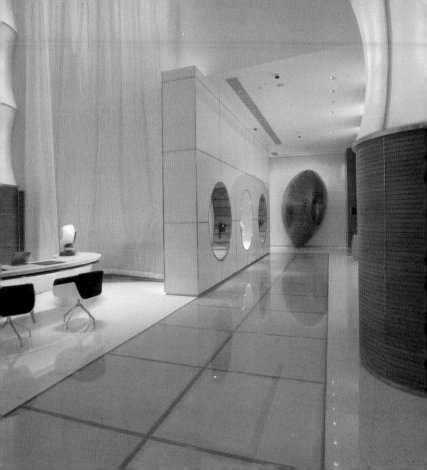

Marco Polo Hongkong Hotel Renovation

Ed Ng, Terence Ngan, AB Concept Ltd.

2005
Ocean Terminal
Tsimshatsui
Kowloon

www.marcopolohotels.com
www.abconcept.com.hk

A modern makeover has transformed the hotel's main lobby and bar area. Bringing it up-to-speed is a cool palette of creamy sandstones, textured leathers, a geometrically sculptural stair, mood-making lighting and subtle Chinese touches such as the bamboo leaf rugs.

Die letzten Modernisierungsmaßnahmen betrafen das Foyer und den Barbereich des Hotels. Cremefarbener Sandstein, strukturiertes Leder, eine geometrisch angelegte Treppe, stimmungsvolles Licht und dezente chinesische Einflüsse, wie Teppiche aus Bambusblättern, sorgen für ein zeitgenössisches Ambiente.

Les récents travaux de modernisation ont porté sur le hall et le bar de l'hôtel. Du grès crème, du cuir structuré, un escalier disposé géométriquement, un éclairage d'ambiance et des influences vaguement chinoises, telles que des tapis en feuilles de bambou, créent une atmosphère contemporaine.

Las últimas reformas se han llevado a cabo en el vestíbulo y la zona de bar del hotel. El resultado se compone de piedra arenisca de tonos crema, piel texturada, una escalera ubicada geométricamente, luz cargada de ambiente y ligeros toques de influencia china, como alfombras de hojas de bambú, todo ello pensado para dar un carácter contemporáneo.

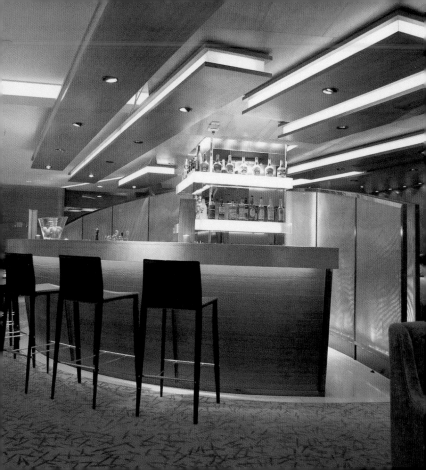

Novotel Citygate Hong Kong

Managed by Accor
AGC Design
Alan Chan
Arquitectonica
Glamorous Co. Ltd.
Graphia
Steve Leung
Urbis Ltd.

2006
51 Man Tung Road
Tung Chung

www.accorhotels.com/asia
www.agcdesign.com.hk
www.alanchandesign.com
www.arquitectonica.com
www.glamorous.co.jp
www.graphiabrands.com
www.steveleung.com
www.urbis.com.hk

Conveniently placed for the Airport, yet effectively tied into Tung Chung's speedy transportation links, the hotel treats its executive guests to a galaxy of modern amenities. The 440 guestrooms and suites are stylishly appointed for the business traveler with no compromises on technology.

In bequemer Nähe zum Flughafen und gut an die schnellen Tung-Chung-Verkehrsverbindungen angeschlossen, bietet das Hotel seinen Gästen alle erdenklichen modernen Annehmlichkeiten. Die 440 schicken Zimmer und Suiten sind passend für Geschäftsreisende eingerichtet und lassen von der technischen Ausstattung her keine Wünsche offen.

A distance confortable de l'aéroport et bien relié aux moyens de transport rapides de Tung Chung, cet hôtel propose à ses hôtes tout le raffinement moderne imaginable. Les 440 élégantes chambres et suites, spécialement aménagées pour les hommes d'affaires, sont en mesure de satisfaire toutes leurs exigences en matière de technologie.

A poca distancia del aeropuerto y bien comunicado con las rápidas conexiones de transporte Tung Chung, el hotel propone a sus huéspedes todas las comodidades modernas posibles. Las 440 habitaciones y suites son refinadas, disponen de todo detalle en tecnología y están diseñadas de forma acorde a los deseos de los viajeros de negocios.

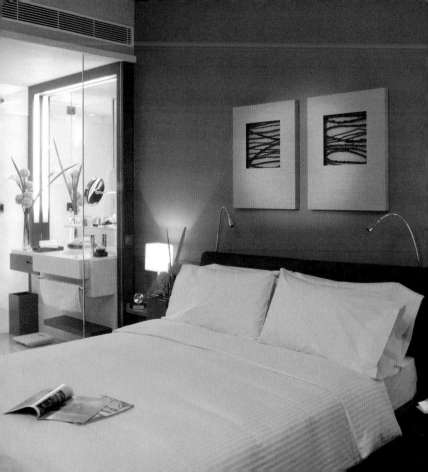

The Landmark Mandarin Oriental

Peter Remedios
Chhada Siembieda Australia

2005
15 Queen's Road Central
The Landmark
Central

www.chhada.com
www.mandarinoriental.com/landmark

Described as a small grand hotel, the emphasis is on quality and uniqueness in the modern vernacular of Asian-inspired luxury. Seamless technology and spa-like bathrooms are married with a glint of old-world colonial charm in the 113 lavishly decked guestrooms.

Es wird als kleines Grandhotel beschrieben, denn sein Schwerpunkt liegt auf Qualität und Einzigartigkeit, eingebettet in modernen, asiatisch angehauchten Luxus. Neueste Technologie und Spa-ähnliche Badezimmer vereinen sich in den 113 verschwenderisch ausgestatteten Zimmern mit einer Spur von altem Kolonialcharme.

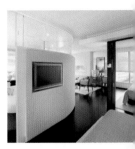

Il passe pour être un petit Grand Hôtel, car il met l'accent sur la qualité et la singularité dans un luxe moderne d'inspiration asiatique. Une technologie dernier cri et des salles de bain semblables à des salles de spa se retrouvent dans les 113 chambres à l'aménagement sophistiqué avec une pointe de l'ancien charme colonial.

Se le suele denominar pequeño Grand Hotel, lo que encaja perfectamente para un lugar que da prioridad en una calidad y exclusividad insertadas en un fondo de lujo con aire asiático. Las 113 ostentosas habitaciones con un toque de encanto colonial disponen de la tecnología más avanzada baños de línea spa y suelos de madera negra pulida.

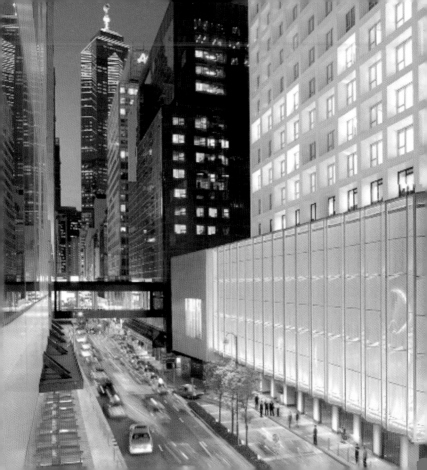

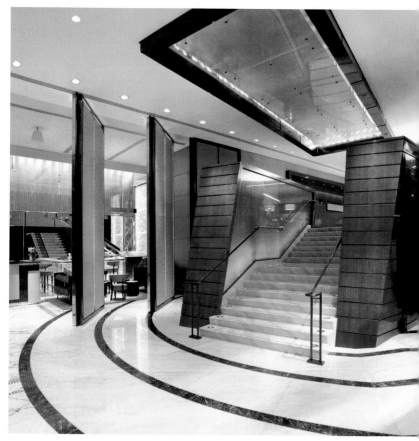

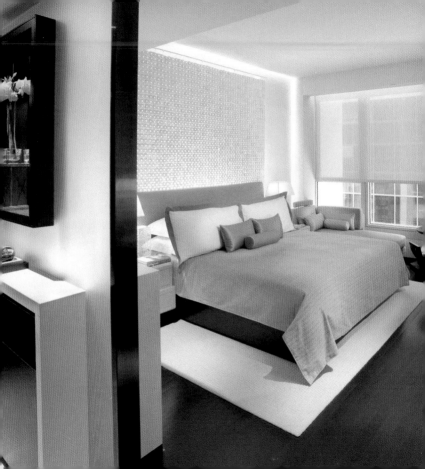

to go . eating
drinking
clubbing
wellness, beauty & sport

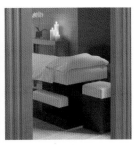 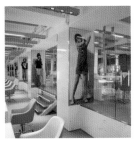 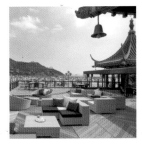

Dong Lai Shun

Steve Leung

2004
The Royal Garden Hotel
69 Mody Road
Tsimshatsui East
Kowloon

www.rghk.com.hk
www.steveleung.com

Bucking the trend of traditional regional cuisine in a modern setting, the interiors are presented as a Chinese aristocratic residence. Luxury and comfort are punctuated by over-scaled lanterns stenciled with cultural motifs that loom over the dining tables.

Entgegen dem Trend, traditionelle regionale Küche in modernem Ambiente zu servieren, präsentiert sich diese Innenausstattung im Stil einer chinesischen, aristokratischen Residenz. Die luxuriöse Einrichtung wird durch überdimensionale Lampen über den Esstischen akzentuiert, die Scherenschnitte kultureller Motive zeigen.

Ici, contrairement à la tendance de faire servir une cuisine traditionnelle régionale dans un décor moderne, la décoration intérieure revêt le caractère d'une résidence aristocratique chinoise. Le luxueux aménagement est accentué par d'énormes lampes au-dessus des tables dont les silhouettes découpées représentent des motifs culturels.

En contra de la moda de servir cocina tradicional regional en un ambiente moderno, en este lugar se presenta el diseño del interior en el estilo de una residencia de la aristocracia china. La lujosa decoración se acentúa con lámparas sobredimensionadas del techo situadas sobre las mesas y decoradas siluetas con finos motivos culturales recortados.

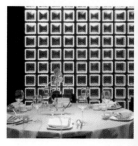

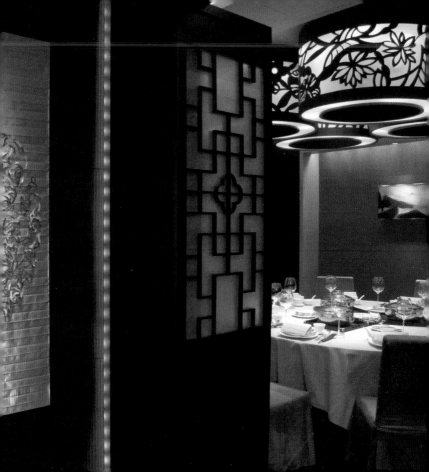

Dragon-i

India Mahdavi
Hérve Bourgeois
Guillaume Richard

2002
60 Wyndham Street
Central

www.dragon-i.com.hk
www.india-mahdavi.com

Assisted by a covered open-air terrace and the chic mystique of its Oriental minimalism interiors, Dragon-i is lounge dining at its hippest. It is also celebrity city, where star spotting is discreetly pursued under over-scaled crimson lanterns and around giant birdcages.

Dragon-i steht für modernstes Lounge-Dining. Dazu gehören eine überdachte Terrasse und der mystische Schick eines minimalistischen fernöstlichen Interieurs. Es ist auch der Ort der Reichen und Schönen, wo diskretes „Promi-Spotting" unter überdimensionalen Purpur-Laternen und zwischen riesigen Vogelkäfigen möglich ist.

Dragon-i incarne le dernier cri des dîners en salon, aidé en cela par une terrasse couverte et le chic mystique d'un intérieur minimaliste d'Extrême-Orient. C'est le point de rencontre des riches et des élégantes où se chuchotent les potins sur les célébrités, sous d'énormes lanternes pourpres et entre des volières géantes.

Dragon-i es la viva imagen del más moderno Lounge-Dining. Para ello es necesario una terraza cubierta, y el refinamiento místico del interior minimalista del lejano oriente. También es el lugar de los guapos y los ricos que se dejan ver discretamente entre faroles púrpura y grandes jaulas para pájaros.

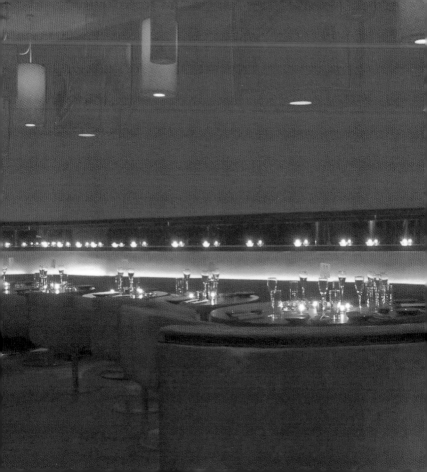

Drop

Dan Evans
Tracey Stoute

2001
Basement, 39-43 Hollywood Road
Central

www.drophk.com

Formerly a basement storage warehouse and discreetly hidden at the end of a non-descript alley, Drop is a relaxed dance venue disguised as a seductive martini lounge. Uniform paneled walls play off against other finishes such as mirror and cream cushioned leatherette.

Eine ehemalige Kellerlagerhalle, die am Ende einer unscheinbaren Gasse liegt, beherbergt heute das Drop – einen relaxten Tanztreff, getarnt als verführerische Martini-Lounge. Einheitlich vertäfelte Wände konkurrieren mit anderen Wandverkleidungen, wie Spiegel und cremefarbene Polsterungen aus Kunstleder.

Cet ancien entrepôt en sous-sol, situé au fond d'une ruelle insignifiante, abrite aujourd'hui le Drop, un dancing à l'ambiance décontractée, déguisé en séduisant Salon Martini. Les murs aux lambris homogènes sont en contraste avec d'autres revêtements, tels que des miroirs et des canapés capitonnés couleur crème en cuir synthétique.

Lo que fue un sótano almacén al final de un callejón que pasa desapercibido, alberga hoy el Drop, un relajante local de baile transformado en atractivo Martini-Lounge. Las paredes entarimadas uniformemente se integran con otros revestimientos, como espejos y tapizados color crema de piel sintética.

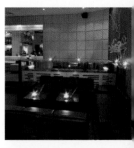

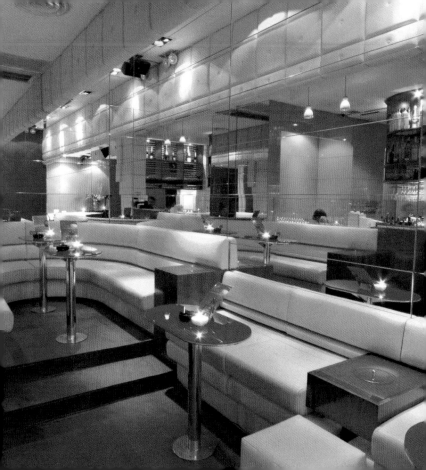

FINDS

David Buffery

2004
2nd Floor, LKF Tower
33 Wyndham Street
Central

www.aedas.com
www.finds.com.hk

Its name is plucked from the first letters of the five Nordic countries, and the décor is appropriately frosty with iced walls and curtains of shimmering crystal. The sensual white curves of the bar area contrast with the brilliant aquamarine leatherette, and a large rotating banquette invites to sit down.

Der Name entstand aus den Anfangsbuchstaben der fünf nordischen Länder – das Dekor ist entsprechend frostig, mit Eiswänden und Vorhängen aus schimmerndem Kristall. Die sanften weißen Kurven des Barbereichs kontrastieren mit leuchtend aquamarinblauem Kunstleder, eine große, drehbare Sitzgruppe lädt zum Verweilen ein.

Le nom est formé à partir des premières lettres des cinq pays scandinaves – c'est pourquoi le décor est si glacé, avec des murs de glace et des rideaux de cristal scintillant. Les arrondis blancs et délicats autour du bar blanc contrastent avec un cuir synthétique d'un bleu aigue-marine lumineux et avec la grande banquette tournante.

El nombre proviene de las iniciales de los cinco países nórdicos, y la decoración transmite igualmente un aire helado, de paredes de hielo y cortinas de cristal brillante. Las curvas blancas y suaves del bar contrastan con la luminosa piel artificial azul marino y la butaca circular que incita a dejar correr el tiempo.

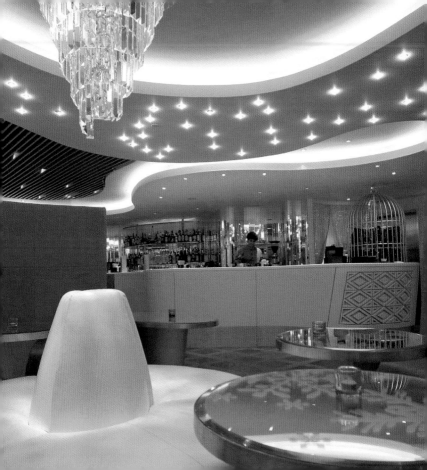

Isola bar + grill

Hugh Zimmern, Leigh & Orange Ltd.

2004
Level 3 & 4, ifc mall
8 Finance Street
Central

www.isolabarandgrill.com
www.leighorange.com

By virtue of its position fringing the harbor, Isola capitalizes on its spectacular views. A white-on-white canvas is overlaid with an intricate, metal filigree lattice that casts shadows on the walls behind. Dining is relaxed by open, marble-topped kitchen workstations and re-used unfinished pine floors.

Aufgrund seiner Lage am Hafen begeistert das Isola mit einer spektakulären Aussicht. Eine weiße Filigranarbeit aus Metall wirft Schattenmuster auf die dahinter liegenden hellen Wände. Man speist entspannt auf unbehandelten, wiederverwerteten Fußböden aus Kiefernholz neben offenen, marmorverkleideten Kochstationen.

Les clients sont enthousiasmés par la vue spectaculaire qu'offre Isola, situé en bordure du port. Un ouvrage de filigrane blanc en métal projette des ombres sur les murs clairs du fond. On dîne détendu, à côté de cuisson au revêtement de marbre, sur des sols en bois de pin recyclés non traités.

Su ubicación en el puerto con las espectaculares vistas hacen de Isola un lugar increíblemente atrayente. Un refinado trabajo de filigrana blanca de metal lanza dibujos de sombras sobre el fondo claro de las paredes. Aquí se disfruta de la comida relajadamente, entre fogones revestidos de mármol y suelos de madera de pino reciclada non tratada.

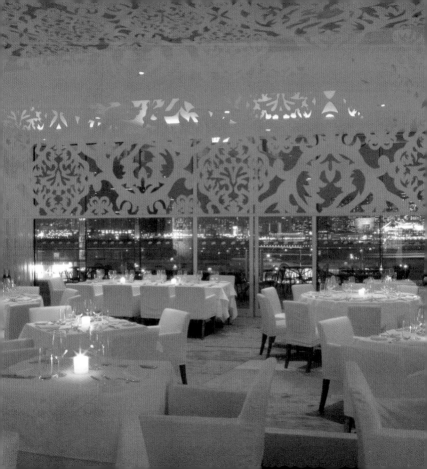

MO Bar

Adam Tihany

2005
The Landmark Mandarin Oriental
15 Queen's Road Central
Central

www.mandarinoriental.com/landmark

The eyes are dazzled by a self-illuminated catwalk bar which is intersected by a "drawbridge" feature suspended over it. Cool Paonazzo marble floors contrast with lush velvets and copper-tinged walls. Flanking the end of the double height volume is the signature red circle, symbolic of shared experiences.

Die Augen werden von der erleuchteten Laufsteg-Bar, die von einer „Zugbrücke" überspannt wird, geblendet. Die kühlen Böden aus Paonazzo-Marmor stehen in Kontrast zu üppigem Samt und kupferfarbenen Wänden. An der Stirnseite des doppelstöckigen Raumes schwebt das Abbild eines roten Kreises, das Symbol gemeinsamer Erfahrungen.

Les yeux sont éblouis par un bar illuminé, en forme de podium, surplombé d'un « pont-levis ». Les sols, froids, en marbre de Paonazzo, contrastent avec les velours chaleureux et les murs cuivrés. Au fond de cet espace d'une hauteur de deux étages est suspendue l'image d'un cercle rouge, le symbole des expériences communes.

La vista queda deslumbrada por la barra de bar iluminada e insertada a un "puente de levadizo" suspendido sobre ella. Los fríos suelos de mármol de Paonazzo crean contraste con el exuberante terciopelo de las paredes en tono cobre. Sobre la pared central de este espacio de dos plantas flota la imagen de un círculo rojo, símbolo de la experiencia en común.

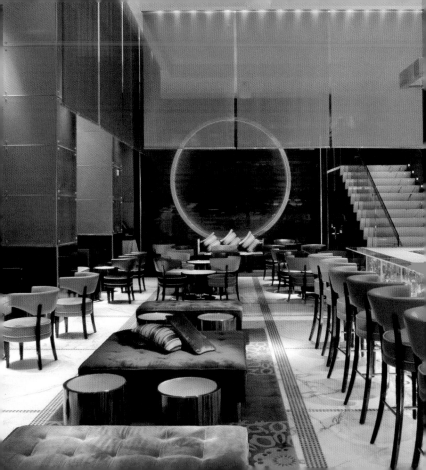

MX

Steve Leung
Alan Chan

2005
Nam Tin Building
275 King's Road
North Point

www.maxims.com.hk/html/fastfood/
www.steveleung.com
www.alanchandesign.com

Undeniably retro in form, the red and white color palette is as hot as the culinary experience is cool. Hong Kong's fast food empire added a surprising twist to its menu when it rebranded its décor and dining concept, blending elements of Chinese culture with upbeat vibes.

Unbestreitbar retro: Die rote und weiße Farbgebung ist so heiß, wie die kulinarischen Genüsse trendig-cool sind. Hong Kongs Fastfood-Imperium gab seinem Menü einen überraschenden Touch, als es Dekoration und Speiseplan neu gestaltete und Elemente der chinesischen Kultur mit Innovativem verband.

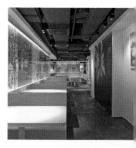

Indéniablement rétro : les harmonies de rouge et blanc sont aussi chaudes que les plaisirs culinaires sont tendances cool. L'empire du fast-food de Hong Kong a donné à son menu une touche surprenante en renouvelant sa décoration et sa carte et en intégrant des éléments de la culture chinoise avec des idées innovantes.

Indiscutiblemente retro: Un rojo y blanco efervescente y un derroche de placeres culinarios de moda. El imperio de la comida rápida de Hong Kong dio a su menú un toque sorprendente al concebir una nueva decoración y plan de menús vinculándolos a elementos de la cultura china y otras innovaciones.

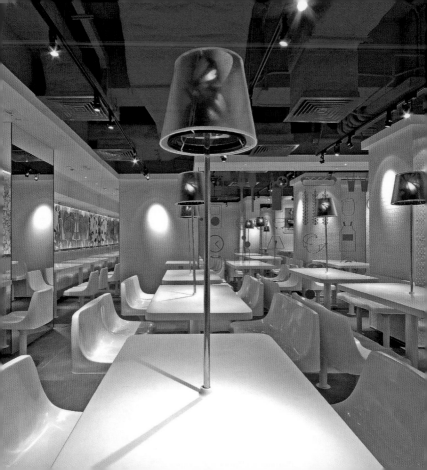

OPIA

André Fu (AFSO)

2005
JIA Hong Kong
1-5 Irving Street
Causeway Bay

www.jiahongkong.com

The restaurant and lounge is discreetly buried behind the façade of Philippe Starck's boutique hotel and accessed via a double-height stairwell with cascading chandelier. As the name suggests, the emphasis is on "vision" with rich opulent velvets reflected in walls of faceted mirror.

Restaurant und Lounge verbergen sich hinter der Fassade des Boutique-Hotels von Philippe Starck und sind über einen hohen Treppenschacht mit üppigem Kronleuchter zugänglich. Wie der Name vermuten lässt, steht hier der optische Eindruck im Mittelpunkt. So wird der prächtige Samt durch Spiegelwände vervielfältigt.

Le restaurant et le salon, cachés derrière la façade de cet hôtel-boutique de Philippe Starck, sont accessibles par une haute cage d'escalier décorée d'un lustre imposant. Le nom de l'établissement semble suggérer qu'ici, l'accent est mis sur l'apparence. Ainsi les somptueux velours se reflètent-ils sur les murs de miroirs à facettes.

El restaurante y el lounge se esconden tras la fachada del Boutique-Hotel de Philippe Starck. Se accede a través de un hueco de escaleras con esplendorosas lámparas de araña. Como se desprende del nombre, el centro de atención lo compone la impresión óptica; ejemplo de ello es el suntuoso terciopelo que se hace infinito en las paredes de espejo.

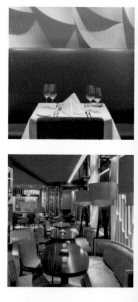

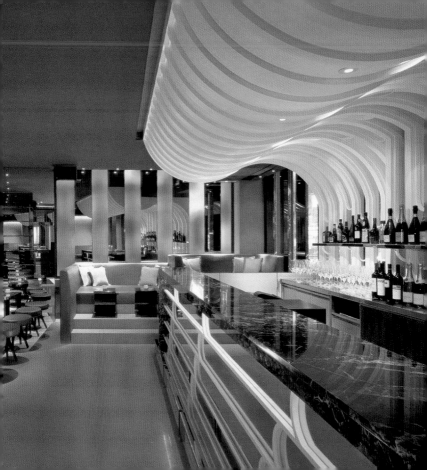

Top Deck at the Jumbo

Cafe Deco Group in collaboration with LRF Designers Ltd.

2005
Top Floor, Jumbo Kingdom
Shum Wan Pier Drive
Aberdeen

www.cafedecogroup.com
www.lrfdesign.com

Aptly named for its elevated, alfresco position on the rooftop of the iconic Jumbo floating restaurant, the interiors combine original fixtures and fittings with contemporary Asian touches. Guests enter a main pavilion under a soaring three-story Chinese pagoda roof.

Der Name passt zur erhöhten Lage unter freiem Himmel auf dem Dach des berühmten schwimmenden Jumbo-Restaurants. Im Innern wird eine traditionelle Möblierung mit zeitgenössischen asiatischen Einflüssen kombiniert. Den Eingang des Hauptpavillons überspannt ein drei Stockwerke hoch aufragendes chinesisches Pagodendach.

Le nom de l'établissement décrit bien son emplacement en plein air sur le toit du célèbre restaurant flottant Jumbo. A l'intérieur, un ameublement traditionnel se conjugue avec des influences asiatiques contemporaines. Un toit en forme de pagode chinoise de trois étages surplombe l'entrée du pavillon principal.

El nombre encaja con su ubicación elevada flotando al aire libre, sobre el tejado del famoso restaurante Jumbo. Los interiores están dotados de mobiliario tradicional combinado con influencias asiáticas contemporáneas. Sobre la entrada del pabellón principal se extiende un tejado chino de pagoda que abarca tres plantas.

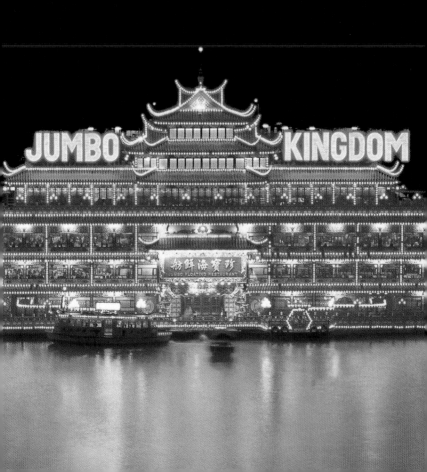

Ye Shanghai Kowloon

ec studio

2002
Marco Polo Hongkong Hotel
Ocean Terminal
Tsimshatsui
Kowloon

www.elite-concepts.com

With cuisine that leans to Shanghai, Jiangsu, and Zhejiang, and interiors harking back to 1930s-Shanghai, the venue features a bar and lounge, main restaurant and adaptable private dining suites. The retake on Chinese art deco is evident in the period-style furniture, and light fittings.

Die Küche ist von Shanghai, Jiangsu und Zhejiang inspiriert, während die Einrichtung in das Shanghai der 1930er-Jahre zurück weist. Zur Ausstattung gehören eine Bar und Lounge, ein Hauptrestaurant und private Speisesuiten. Der Einfluss von chinesischem Art déco bei den stilechten Möbeln und Lampen ist unverkennbar.

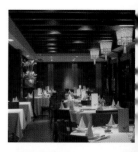

La cuisine s'inspire de Shanghai, du Jiangsu et du Zhejiang, tandis que la décoration remonte au Shanghai des années 1930. L'établissement comprend un bar avec un salon, une salle de restaurant principale et des suites pour dîner en privé. L'influence de l'art déco chinois pour les meubles de style authentiques et les lampes est évidente.

Una cocina inspirada en Shanghai, Jiangsu y Zhejiang, y un interior que traslada el Shanghai de 1930. En este entorno se incluyen bar y lounge, un restaurante principal y suites comedor privadas. La influencia del Art déco chino se hace evidente en muebles y lámparas de estilo auténtico.

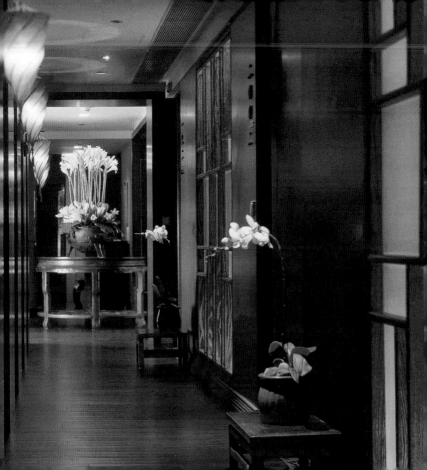

Headquarters

Steve Leung

2004
Pacific House
20-20B Queen's Road Central
Central

www.steveleung.com

An exercise in monochromatic, sepia-washed space, hair stations convey dressing-room style, but without the harsh lighting. Privacy is achieved through careful orientation of free-standing furniture, and wafting white gauzy drapes that also help warm and soften the ultra-cool surfaces.

Mit monochromen, sepiagetönten Räumen erinnert der Friseur stilistisch an eine Ankleide, jedoch ohne das grelle Licht. Die sorgfältige Anordnung frei stehender Möbel und wehende weiße Gazevorhänge schaffen nicht nur Privatsphäre, sondern mildern auch den Eindruck der kühl wirkenden Oberflächen.

Avec une monochromie de teintes sépia, les espaces, chez ce coiffeur, rappellent le style d'un dressing-room mais sans l'éclairage cru. La disposition étudiée de meubles isolés et les rideaux ondoyants de gaze blanche créent non seulement une intimité mais atténuent aussi l'impression de froideur que dégagent les surfaces.

Las monocromas estancias en sepia de esta peluquería recuerdan a un vestidor, ahora bien, sin la luz estridente. La cuidadosa disposición de los muebles situados libremente y las ondulantes cortinas de gasa blanca aportan no sólo ambiente de privacidad sino que además reducen la impresión de frialdad de las superficies.

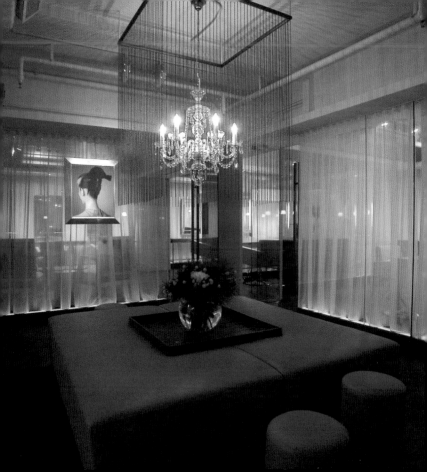

Hillgrove Clubhouse

Edge Design Institute Ltd.

2001
Siu Lam
New Territories

www.edgedesign.com.hk

The architecture attempts to blend and integrate the facilities with its surroundings, rendering them indistinguishable. This is largely achieved through reflective materials, such as giant panes of textured glass and the Norwegian stone floors with their metallic sheen.

Die Gestaltung zielt auf eine Mischung und Verbindung der Einrichtung mit der Umgebung ab, so dass beide nicht mehr voneinander zu unterscheiden sind. Erreicht wird dies durch reflektierende Materialien, wie riesige Scheiben aus strukturiertem Glas und norwegische Steinböden mit metallischem Glanz.

Le concept architectural tend à mêler et intégrer les installations à leur environnement pour les rendre impossibles à distinguer. Cet objectif est réalisé grâce à des matériaux réfléchissants tels que d'immenses vitres de verre structuré et un dallage norvégien d'un éclat métallique.

El diseño está orientado a fusionar la decoración con el entorno, de manera que sean indistinguibles. El efecto se alcanza a través de materiales reflectantes, tales como gigantescas placas de cristal estructurado y suelos de piedra noruega de brillo metálico.

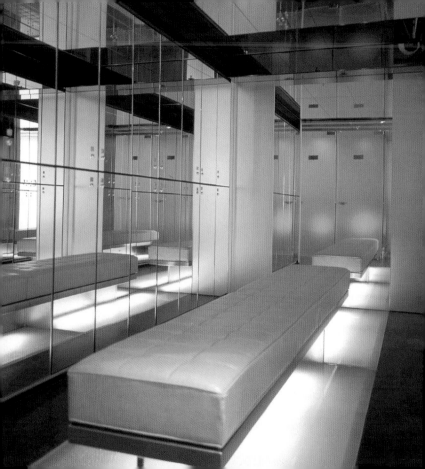

Spa MTM

Patrick Leung, PAL Design Consultants Ltd.

2005
Shop A, G/F, 3 Yun Ping Road
Causeway Bay

www.mtmskincare.com
www.paldesign.cn

A double-height space outlined by textured white paintwork sets the scene to the urban sanctuary of treatment studios and Jacuzzi or steam rooms. A gracefully designed stair ties both floors together and forms a striking sculptural focus. Subtle light and shadow effects provide an appropriate aura of calm.

Doppelte Raumhöhen und weiße Strukturbemalung bilden die Kulisse für diese urbane Wellnessstätte mit Behandlungsstudios, Whirlpools und Dampfbädern. Eine anmutig gestaltete Treppe verbindet beide Etagen und stellt einen eindrucksvollen Blickfang dar. Dezente Effekte mit Licht und Schatten schaffen eine ruhige Atmosphäre.

Double hauteur de plafond, peinture blanche en relief, tel est le décor de ce centre de wellness urbain avec instituts de soins, espaces jacuzzis et bains de vapeur. Un escalier de belle facture reliant les deux étages attire très efficacement le regard. De subtils effets d'ombre et de lumière créent une atmosphère de calme.

Alturas dobles y pintura de estructura blanca son el escenario de este centro wellness urbano que dispone de estudios para tratamientos, whirlpool y baños de vapor. Una garbosa escalera une ambas plantas un escultural punto de atracción. Los discretos efectos de luz y sombra emanan un ambiente de calma.

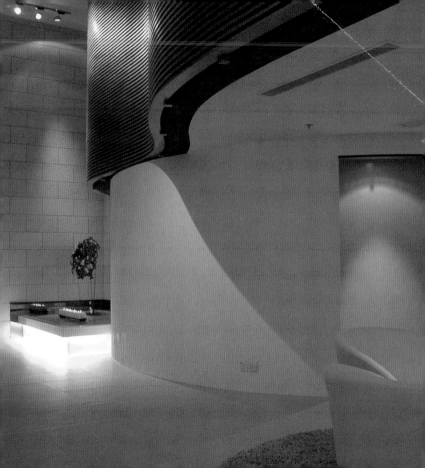

The Organic Pharmacy

Edge Design Institute Ltd.

2005
17 Queen's Road Central
Central

www.theorganicpharmacy.com
www.edgedesign.com.hk

The interiors for the London-based skincare label begin from the premise that every product is unique and equally important. A rational display approach creates an exceptionally strong impact, with the assembled stands producing a three-dimensional wall sculpture.

Das Interieur der Londoner Marke für Hautpflegeprodukte basiert auf dem Prinzip, dass jedes Produkt einzigartig und von gleicher Wichtigkeit ist. Die rationale Präsentation hat eine außerordentlich starke Wirkung, und das Arrangement der Regale gleicht einer Wandskulptur.

Le décor intérieur de cette marque londonienne de produits de beauté pour la peau repose sur le principe que chaque produit est unique et mérite la même attention. Cette présentation rationnelle a un impact très fort et l'agencement des étagères fait penser à une sculpture murale.

El interior de esta londonesa marca para productos del cuidado de la piel se basa en un principio elemental: cada producto es único e igual de importante. La presentación racional es claramente efectiva y la composición de las estanterías parece una escultura ante la pared.

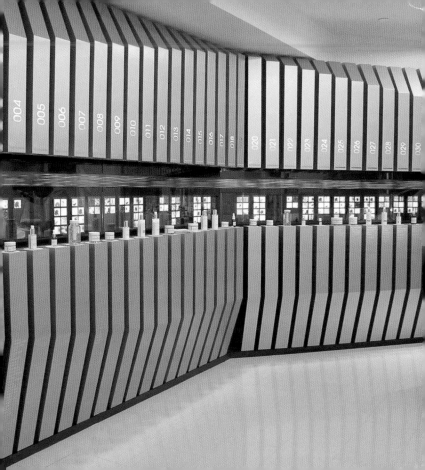

The Oriental Spa

Peter Remedios
Norbert Deckelmann

2005
15 Queen's Road Central
The Landmark
Central

www.mandarinoriental.com/landmark

Occupying two floors of the new Landmark Mandarin Oriental hotel, the comprehensive urban spa includes vitality pools, amethyst crystal steam rooms and Asia's first authentic rhassoul. 15 private treatment rooms including a deluxe VIP suite are decked in a palette of bamboo, natural stone, and gold leaf.

Auf zwei Stockwerken des neuen Landmark Mandarin Oriental Hotels bietet das urbane Spa belebende Pools, Amethystkristall-Dampfräume und Asiens erstes echtes Rasul. 15 Behandlungsräume einschließlich einer Luxus-VIP-Suite sind mit Bambus, Naturstein und Blattgold verkleidet.

Sur deux étages du nouveau Landmark Mandarin Oriental Hotel, ce spa urbain propose des bassins vivifiants, des bains de vapeur au cristal d'améthyste et le premier véritable bain Rasul d'Asie. 15 salles de soins, dont une suite VIP de luxe, sont revêtues de bambou, de pierre naturelle et d'or en feuilles.

En dos de las plantas del nuevo Landmark Mandarin Oriental Hotel se ubica un spa urbano con piscinas revitalizantes, estancias para baños de vapor con cristal de amatista y el primer baño Rasul auténtico de Asia. El entorno dispone de 15 salas de tratamientos y una suite de lujo revestidas de bambú, piedra y pan de oro.

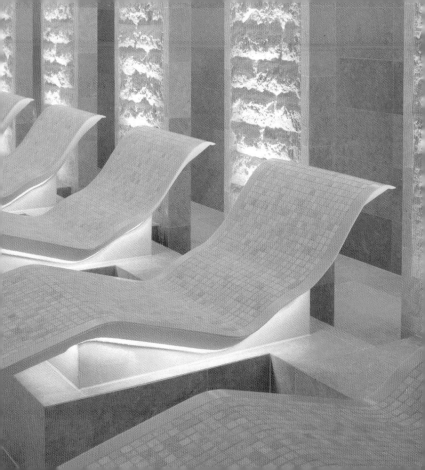

The Smile Spa Dental Practice

Tania Chow

2004
1 Lan Kwai Fong
Central

www.thesmile.com.hk

Comfort and style don't usually describe a visit to the dentist, yet finely tuned detailing and attention to aesthetics are an obvious association with the skills of dentistry. Bright airiness is balanced against cocooned privacy with a sunny palette of warm yellows, leafy greens, and blond timbers.

Komfort und Stil sind nicht typisch für eine Zahnarztpraxis, obgleich Feinarbeit und ein Blick für Ästhetik die Zahnheilkunde auszeichnen. Hier hingegen halten sich helle Luftigkeit sowie eine abgeschirmte Privatsphäre im Gleichgewicht, während die Ausstattung in sonnig-warmem Gelb, Laubgrün und hellen Hölzern gehalten ist.

D'ordinaire, confort et style ne sont pas les qualités d'un cabinet dentaire, même si l'odontologie se caractérise par la précision et le sens de l'esthétique. Ici, en revanche, on rencontre un équilibre parfait entre une légèreté lumineuse et une intimité protégée avec une décoration d'un jaune ensoleillé, d'un vert tendre et de bois clair.

El confort y el estilo no son precisamente la marca significativa de una consulta de dentista, si bien esta profesión se define por el trabajo cuidado y un sentido de la estética. Aquí sin embargo se vive un equilibrio entre una luminosa ligereza y la privacidad, con un equipamiento en amarillo cálido, verde hoja y madera clara.

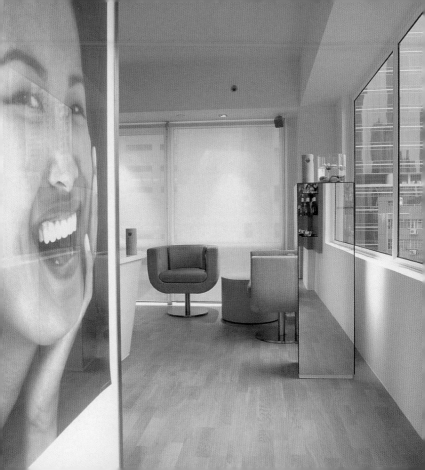

YOGA PLUS

Antony Chan, Cream

2005
5-7/F, 33 Wyndham Street
Central

www.cream.com.hk
www.yogaplus.com.hk

Spanning three floors, the studios follow the guiding principles of "health, fun, and harmony". While citrus lime is the signature color, this does not detract from the overall sense of calm and clarity. Monolithic stretches of natural materials provide a solid grounding to details such as stylised floral motifs.

Die Prinzipien „Gesundheit, Freude und Harmonie" wurden auf drei Etagen gestalterisch umgesetzt. Die vorherrschende Farbe Limette beeinträchtigt nicht die allgegenwärtige Atmosphäre von Ruhe und Klarheit. Gleichmäßige Flächen aus Naturmaterialien bieten einen geeigneten Hintergrund für Details wie stilisierte Pflanzenmotive.

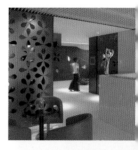

Ici, les principes de « santé, plaisir et harmonie » ont été mis en scène sur trois étages. La couleur dominante vert limette n'altère pas l'atmosphère de calme et de clarté qui règne dans cet endroit. Des surfaces régulières faites de matériaux naturels permettent de faire ressortir agréablement des détails tels que les motifs végétaux stylisés.

Los principios "salud, goce y armonía" se han hecho patentes en el diseño de los diversos pisos. La predominancia del tono lima no reduce en absoluto la atmósfera de claridad y tranquilidad. Las superficies regulares de materiales naturales son el fondo apropiado sobre el que destacan detalles como motivos florales estilizados.

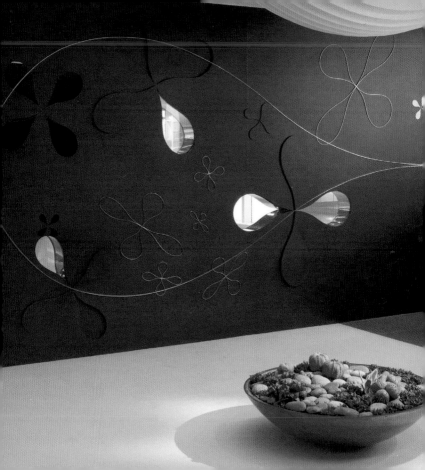

Zenana

Joseph Sy, Joseph Sy & Associates

2005
5/F China Hong Kong Center
122-126 Canton Road
Tsimshatsui
Kowloon

www.zenana.hk
www.jsahk.com

As a haven of holistic health and well-being, the interiors radiate an inner glow of cool blue light and clinical purity. Privacy and seclusion is of utmost importance considering the nature of the many treatments on offer, and this is achieved with flowing sheers and subtle screening.

Als ein Hafen für Gesundheit und Wohlbefinden strahlt die Einrichtung des Zenana klinische Reinheit aus und verströmt kühlblaues Licht. Privatsphäre und Ruhe haben in Anbetracht der angebotenen Behandlungen Priorität, erreicht wird dies durch fließende Vorhänge und diskrete Abschirmungen.

Les installations du Zenana, sanctuaire de santé et de bienêtre, rayonnent de pureté clinique et irradient une lumière d'un bleu d'iceberg. Étant donné la nature des soins proposés, le calme et l'intimité sont essentiels. C'est ce que procurent des rideaux fluides et des discrets paravents.

Este puerto de salud y bienestar se inunda de limpieza clínica y emana una luz fresca de tonos azules. La privacidad y el relax son objetivo prioritario en los tratamientos, lo que se consigue a través de cortinas ligeras y discretas pantallas.

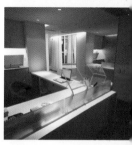

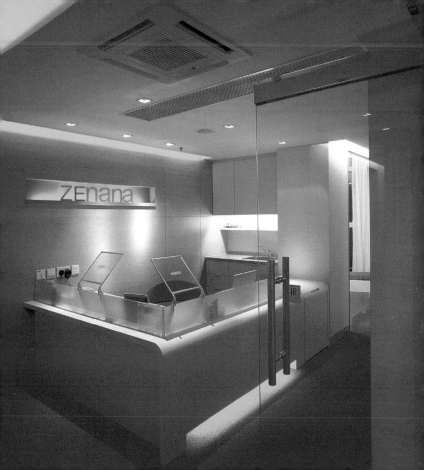

to shop . mall
 retail
 showrooms

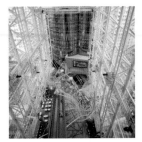
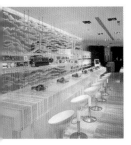
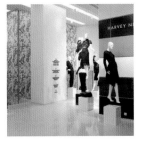
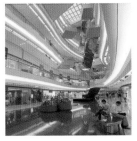
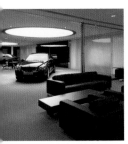
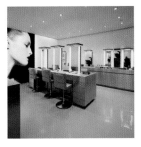
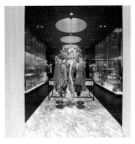

Aesop Concept Shop

Jim Vitogiannis
Dennis Paphitis

2005
G/F, 52-60 Lyndhurst Terrace
Central

www.aesop.net.au

With a product base so clear and uncompromising in its ingredients, it's no surprise that this philosophy is superimposed on Aesop's pure, perfectly integrated interiors and brand packaging, while the aroma adds to the overall sensuality of space.

Es ist keine Überraschung, dass sich die Philosophie der klaren und kompromisslosen Aesop-Produkte auch in den reduzierten, perfekt abgestimmten Innenräumen und den Produktverpackungen widerspiegelt. Die Aromen lassen den Raum indes zu einem sinnlichen Dufterlebnis werden.

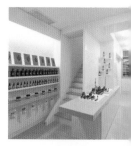

Il n'est pas surprenant de voir que la philosophie des produits Aesop, claire et sans concessions, se reflète également dans les intérieurs sobres et harmonieux et dans l'emballage des produits. En même temps, par la grâce des arômes, l'espace se transforme en aventure olfactive.

No sorprende que la filosofía de claridad y sin compromisos que mantienen los productos Aesop se haga patente en los interiores límpidos y perfectamente coordinados del comercio y en la presentación de los productos. Los aromas que embriagan el entorno crean una experiencia única para los sentidos.

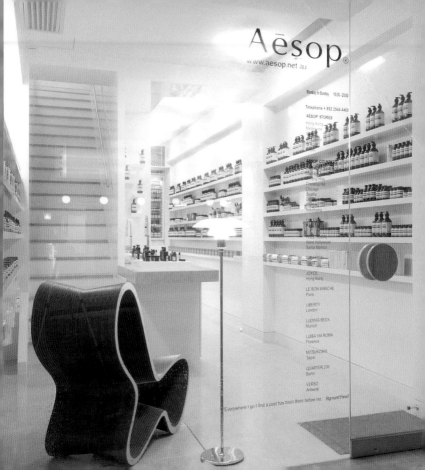

Alain Mikli Boutique

Philippe Starck

2002
G/F, 28 Wellington Street
Central

www.mikli.com
www.philippestarck.com

Visibly sited at the gateway to the wall-to-wall nightlife of Lan Kwai Fong, the white cube of a boutique is distinguished by its monolithic quality, revealing a shallow double-height space once inside, then the finely crafted cases of crystal glass presenting row upon row of spectacles for a sensual appearance.

Diese als weißer Kubus gestaltete Boutique ist auffällig platziert am Eingang von Lan Kwai Fong, wo sich Club an Club reiht, und fällt durch ihr monolithisches Design auf, das im Innern doppelstöckig aufgebaut ist. Die kunstfertigen Vitrinen aus Kristallglas präsentieren reihenweise formschöne Brillen für einen sinnlichen Auftritt.

Le magasin, conçu comme un cube blanc, bien visible, est situé à l'entrée de Lan Kwai Fong où les clubs se suivent les uns après les autres. Son design monolithique, élaboré à l'intérieur sur deux étages, est très frappant. Des commodes vitrines en cristal présentent des rangées de montures de lunettes.

Esta boutique concebida como un cubo blanco ha sido ubicada llamativamente en la entrada de Lan Kwai Fong, puerta a puerta con los locales nocturnos. Resulta un foco de atención por su diseño monolítico, con un interior construido en dos plantas. Las delicadas vitrinas concebidas en vidrio exponen las atractivas filas de gafas como un espectáculo para los sentidos.

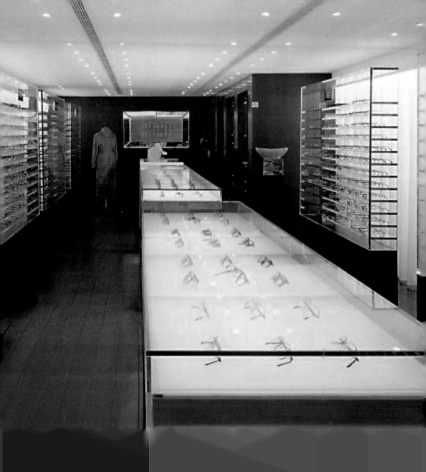

Emporio Armani
Chater House

Doriana & Massimiliano Fuksas
Claudio Silverstrin

2002
11 Chater Road
Central

www.giorgioarmani.com.hk
www.fuksas.it
www.claudiosilverstrin.com

The largest of the luxury label's flagship stores outside Milan, Hong Kong's Armani stronghold contains all the brand lineages from the original Giorgio Armani through to Armani Fiori and Armani Casa. The designer emphasizes minimal fixturing and hyper-transparency with a glass and steel stair.

Hong Kongs Armani-Hochburg, die größte Repräsentationsfläche der Luxusmarke außerhalb Mailands, offeriert alle Produktlinien des Italieners, von Giorgio Armani über Armani Fiori bis Armani Casa. Der Designer bevorzugt eine minimalistische Einrichtung und Hyper-Transparenz mit einer Treppe aus Glas und Stahl.

La citadelle Armani de Hong Kong, la plus grande représentation de la marque de luxe hors de Milan, propose toutes les lignes de produits du créateur italien, avec Giorgio Armani, Armani Fiori et Armani Casa. Le créateur privilégie une décoration minimaliste et une transparence absolue au moyen de grandes surfaces de verre et d'escaliers en acier.

La fortaleza de Armani en Hong Kong, la mayor superficie de representación que posee la marca fuera de Milán, ofrece toda la línea de productos del Italiano Giorgio Armani, pasando por Armani Fiori hasta Armani Casa. El diseñador ha optado por un concepto de decoración minimalista y extremadamente transparente, dotada de una escalera de acero y cristal.

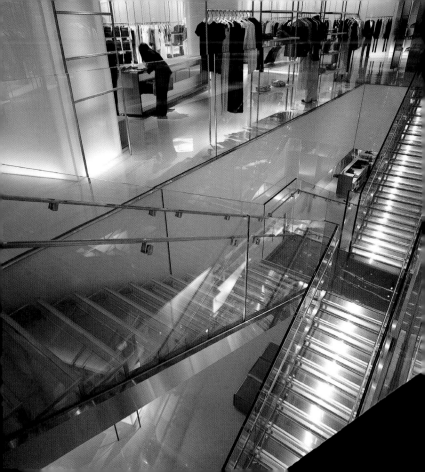

Festival Walk

Arquitectonica
Dennis Lau & Ng Chun Man (HK) Ltd.

1998
80 Tat Chee Avenue
Kowloon Tong

www.arquitectonica.com
www.dln.com.hk
www.festivalwalk.com.hk

With seven floors of shopping, dining, and entertainment, the cavernous architecture of the mall introduces welcome breathing spaces that are airy and full of light. The design promotes visual contact vertically by carving out large voids that are intersected by sculptural floating escalators.

Die verschachtelte Architektur dieser Mall mit sieben Stockwerken für Shopping, Essen und Unterhaltung wirkt einladend aufgrund ihrer lichten und luftigen Raumstruktur. Das Design lenkt die Blickrichtung in die Höhe – durch riesige Leerräume, die von skulpturartigen Rolltreppen unterteilt werden.

L'architecture de ce centre commercial où s'entremêlent sur sept étages le shopping, la restauration et les i... ...duit par son es.. ...eux. Le de.. ...ers le haut ...les entre... ...pendus.

La arquitectura intercalada de esta galería que cuenta con siete plantas con propuestas para ir de compras, comer y de ocio, debe también su atractivo a los juegos de luz y a la vaporosa estructura del espacio. El diseño desvía las miradas hacia lo alto donde se divisan espacios vacíos, recortados por escaleras mecánicas esculturales.

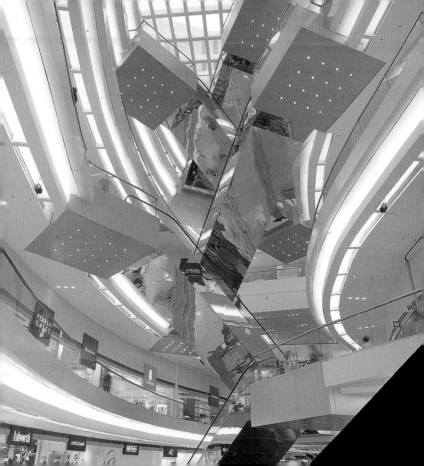

Harvey Nichols Hong Kong

Christian Biecher & Associates

2005
15 Queen's Road Central
The Landmark
Central

www.harveynichols.com
www.biecher.com

The department store spans five levels, creating a vertical interplay of bold graphic statements and intense waves of color. Its façade is delicately patterned in a metal veil of gold "lace", while the interiors—a series of intimate salons—present a surprising interpretation of English style.

Die fünf Ebenen dieses Kaufhauses sind ein vertikales Wechselspiel von grafischen Elementen und intensiven Farben. Die Fassade ist mit einem metallischen Schleier aus goldenen „Spitzen" zart gemustert, während das Innere – eine Reihe intimer Salons – eine überraschende Interpretation des englischen Stils offenbart.

Les cinq niveaux de ce grand magasin offrent une alternance à la verticale d'éléments graphi-
Sa
rée
eur
es –
sur-

Los cinco niveles de este gran almacén conforman un juego vertical de elementos gráficos y colores intensos. La fachada está suavemente decorada con un velo metálico de "puntillas" doradas, mientras que el interior, compuesto por una serie de íntimos salones, resulta una interpretación sorprendente del estilo inglés.

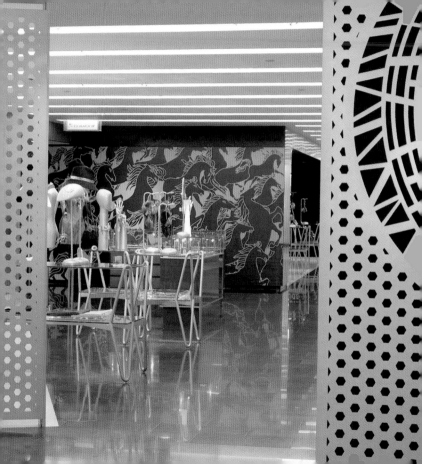

I.T Pacific Place

Masamichi Katayama

2005
Shop 120, Pacific Place
88 Queensway
Admiralty
Wanchai

www.ithk.com
www.wonder-wall.com

The newest addition to the I.T family creates provocative spaces that challenge and inspire. Glass and stainless steel is given a theatrical twist with flowing sheers, and decorative columns. The visual experience is ambiguously blurred by the use of pixelized screens.

Die neueste Errungenschaft der I.T-Familie birgt provokative Räume, die herausfordern und inspirieren. Glas und Edelstahl mischen sich mit fließenden Vorhängen und dekorativen Säulen. Durch die Scheiben von grober Struktur ist der visuelle Eindruck mehrdeutig und verschwommen.

La dernière acquisition de la famille I.T recèle des espaces un brin provocateurs, source d'inspiration et de défi. Le verre et l'acier inoxydable se mêlent à la fluidité des rideaux et à l'esthétique des colonnes. Les vitres à texture pixélisée rendent l'impression visuelle ambiguë et floue.

La última creación de la familia I.T esconde estancias provocativas, que incitan a la inspiración. Cristal y acero inoxidable se funden con cortinas ligeras y columnas decorativas. A través del escaparate de estructura basta el efecto visual se antoja difuso y ambiguo.

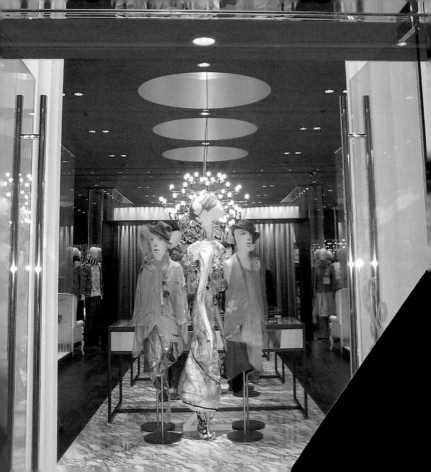

Lane Crawford, ifc mall

George Yabu, Glenn Pushelberg, Yabu Pushelberg

2004
Podium 3, ifc mall
8 Finance Street
Central

www.lanecrawford.com

The flagship department store for fashion and lifestyle assembles contemporary designers and brand names in quiet luxury, choreographed by exquisitely refined materials and original art installations. Special features: the in-store concierge team, martini lounge, CD bar, and cafe.

Das führende Kaufhaus für Mode und Lifestyle versammelt zeitgenössische Designer- und Markennamen in einer äußerst luxuriösen Umgebung, die von erstklassigen Materialien und Installationen mit Originalkunstwerken geprägt ist. Besonders: ein Concierge-Team im Haus, eine Martini-Lounge, eine CD-Bar und ein Café.

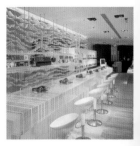

La prestigiosa casa de moda y ~~estilo~~ reúne marcas y diseñado~~res~~ ~~con~~temporáneos en un en~~torno~~ extremadamente lujoso, ~~si~~tuado con materiales de ~~prim~~era calidad e instalaciones ~~con~~ obras de arte originales. El ~~complem~~ento lo ponen el equipo de ~~c~~onserjes de la casa, un Martini-Lounge, un CD-Bar y una cafetería.

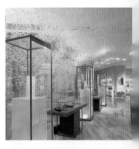

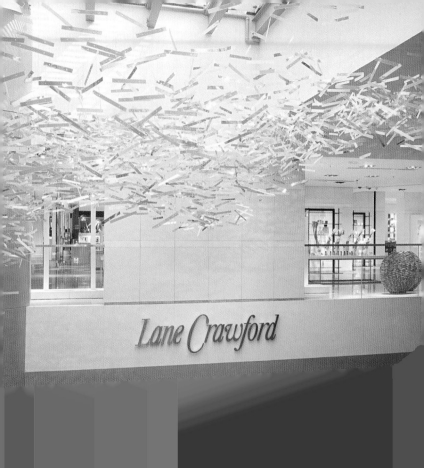

Langham Place

The Jerde Partnership
Wong & Ouyang (HK) Ltd.
Ove Arup & Partners (HK) Ltd. (SE)

2005
555 Shanghai Street
Mongkok
Kowloon

www.jerde.com
www.wongouyang.com
www.langhamplace.com.hk

Despite its scale stretching 15 stories, the shopping experience is surprisingly intricate and unpredictable. The vertical retail center sports Hong Kong's longest unsupported indoor escalators and a nine-story atrium. The expanse of glass is offset by sheer granite walls.

Trotz einer Ausdehnung von 15 Stockwerken ist das Einkaufserlebnis überraschend komplex und unberechenbar. Das hoch aufragende Einkaufszentrum wartet mit Hong Kongs längster frei schwebender Innenrolltreppe und einem neunstöckigen Atrium auf. Die Weite der Glasflächen wird von Wänden aus reinem Granit unterbrochen.

Répartie sur 15 étages, l'aventure du shopping e- am-
ment ble
out
du
ue
g
s

Teniendo a la disposición un espacio de 15 plantas es lógico que la experiencia de ir de compras se haga sorprendentemente intrincada e impredecible. Este centro comercial vertical alberga en su interior la escalera mecánica suspendida más larga de Hong Kong, además de un atrio de nueve pisos. Las enormes superficies de cristal se ven interrumpidas por paredes de granito puro intercaladas.

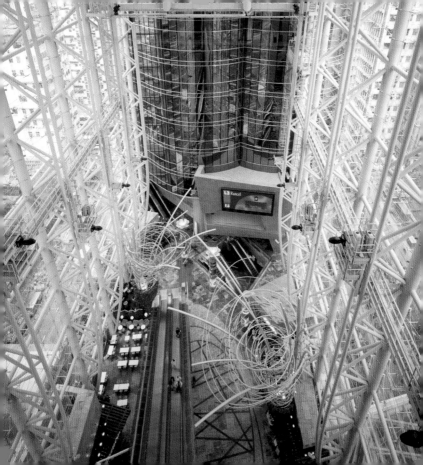

Maybach Centre of Excellence

Johnny Kember, KplusK associates

2003
60 Repulse Bay Road
Repulse Bay

www.kplusk.net

Sited in a historic 1927-built Studebaker garage, the faithful restoration to the original structure is offset by an elegant, technologically-driven interior that underpins the Maybach brand. The cars are haloed under floating light panels in the ceiling that simulate different daylight conditions.

Das Center befindet sich in einer originalgetreu restaurierten historischen Studebaker-Werkstatt aus dem Jahr 1927. Das Interieur ist, wie die Marke selbst, elegant und dabei hochtechnologisch ausgestattet. Die Wagen schimmern unter großen Lichtelementen, die variierende Tageslichtbedingungen simulieren.

Le centre se trouve dans un atelier Studebaker historique, fidèlement restauré, datant de l'année 1927. À l'instar de la marque même, l'intérieur est élégant et doté d'équipements de haute technologie. Les voitures scintillent sous de larges éclairages qui simulent différentes conditions de lumière du jour.

El centro está ubicado en un garaje de Studebaker del año 1927 que ha sido restaurado manteniendo fielmente el estilo original. El interior, al igual que la propia marca, está dotado de elegancia y alta tecnología. Los vehículos resplandecen bajo elementos de luz simulando condiciones de luz diurna variadas.

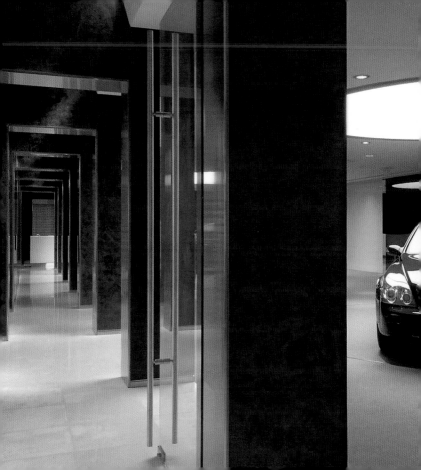

OVO home & OVO garden

Ed Ng & Terence Ngan, AB Concept Ltd. (OVO home)
Dan Lee & Calvin Ching, EGG Design Ltd. (OVO garden)

2005
22 Queen's Road East (OVO home)
16 Wing Fung Street (OVO garden)
Wanchai

www.ovo.com.hk
www.ovogarden.com.hk
www.abconcept.com.hk
www.eggdesign.com.hk

A temple to modern Oriental living, the store is designed as a series of room settings perfectly styled in the minutest detail. Geometric forms, exquisite timbers and designed screens take center-stage. Ovo garden introduces the same concept to the outdoors with natural materials.

Dieses Geschäft ist ein Tempel für modernes fernöstliches Leben und erschaffen als Arrangement von bis ins kleinste Detail perfekt konzipierten Räumen. Geometrische Formen, edelste Hölzer und gestaltete Wände stehen im Mittelpunkt. Ovo garden überträgt dieses Konzept nach außen und setzt dabei auf Naturmaterialien.

Ce magasin, temple d'un mode de vie extrême-oriental moderne, est une succession d'espaces parfaitement conçus dans le moindre détail. Des formes géométriques, des bois précieux et des cloisons façonnées sont les éléments de base. Ovo garden applique également ce concept de décoration à l'extérieur et mise pour cela sur des matériaux naturels.

Es el templo del estilo de vida oriental moderno y está concebido como un conjunto perfilado con perfección hasta en el más minucioso detalle. El centro de atención lo captan las formas geométricas, las maderas más nobles y paredes decoradas. Ovo Garden transmite este concepto de diseño hacia el exterior integrando materiales naturales.

174

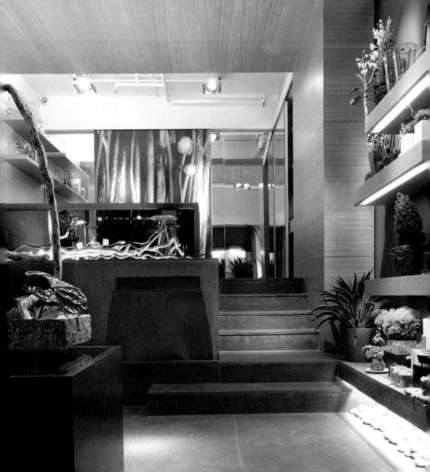

Qeelin

Steve Leung

2005
The Peninsula Shopping Arcade
Salisbury Road
Tsimshatsui
Kowloon

www.qeelin.com
www.steveleung.com

Illusion and mystique are applied in equal measure, tantalizing those who enter this chamber of glamour. A black mirrored ceiling creates the impression of a double-height space. This magnifies the dimensions on a grand scale, highlighting the red monolithic walls and delicate crystal curtains.

Jeder, der diesen glanzvollen Saal betritt, erliegt dessen Illusion und Zauber. Die Decke aus schwarzem Spiegelglas erweckt den Eindruck doppelter Raumhöhe. Die Dimensionen des Raumes werden erweitert, und auf diese Weise werden die roten Steinwände sowie die Kristallvorhänge hervorgehoben.

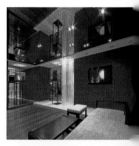

Quiconque pénètre dans cette salle magique succombe à l'illusion et à l'enchantement. La glace noire du plafond suscite une impression de double hauteur. La pièce paraît plus grande, ce qui met particulièrement en valeur les murs de pierre rouges et les rideaux de cristal délicat.

Cualquiera que se introduzca en esta esplendorosa sala vivirá la ilusión y el encantamiento. El techo de cristal de espejo negro proporciona una sensación de doble altura. Con ello, las dimensiones de la estancia se amplían poniendo de relieve las paredes rojas de piedra y las suaves y cristalinas cortinas.

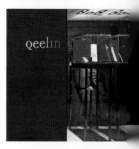

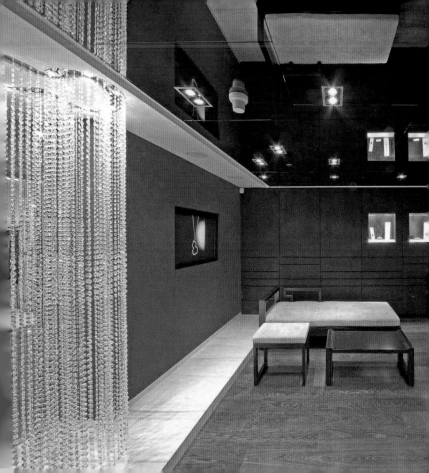

The Arcade at Cyberport

The Jerde Partnership
Wong Tung Partners Ltd.
Ove Arup & Partners (HK) Ltd. (SE)
Maunsell Structural Consultants (SE)

2004
100 Cyberport Road
Pokfulam

www.jerde.com
www.cyberport.hk

Conceived as the commercial and cultural heart of the high-tech business enclave, The Arcade is easily identified by its iconic roof. A combination of sophisticated technology, natural materials, and rich landscaping create an experiential village for shopping, dining and entertainment.

The Arcade, das kommerzielle und kulturelle Herz der High-Tech-Enklave Cyberport, ist leicht an seinem charakteristischen Dach erkennbar. Anspruchsvolle Technologie, natürliche Materialien und eine vielseitige Landschaftsgestaltung sind hier vereint zu einer praktischen Anlage zum Shoppen, Essen und Sich-Vergnügen.

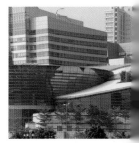

The Arcade, le cœur commercial et culturel de l'enclave à haute technologie Cyberport, est facilement identifiable à son toit caractéristique. Une technologie de pointe, des matériaux naturels et une conception paysagère diversifiée ont permis de créer un emplacement pratique pour le shopping, la restauration et les loisirs.

The Arcade, el centro comercial y cultural del enclave High-Tech de Cyberport, es fácilmente reconocible por su tejado característico. Tecnología punta, materiales naturales y una concepción polifacética del entorno se aúnan creando unas instalaciones prácticas para ir de compras, comer y divertirse.

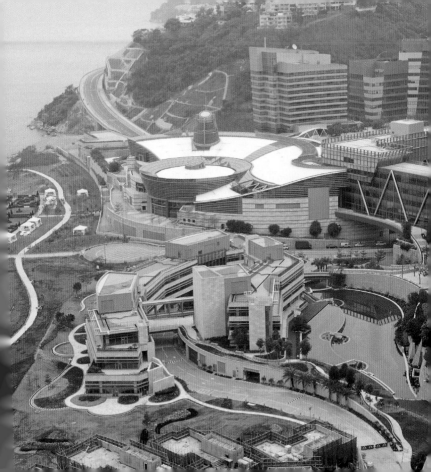

The Landmark Phase 2
Mandarin Oriental Hotel

Kohn Pedersen Fox Associates PC
Maunsell Structural Consultants (SE)

2006
15 Queen's Road Central
The Landmark
Central

www.kpf.com
www.mandarinoriental.com/landmark

The upgrade preserves its distinction as one of Hong Kong's premier retail addresses, bolstered by the addition of a boutique hotel, spa, and 23-story office tower. Screening the exterior of the retail space is a diaphanous veil of vertically "folded" glass panels.

Die Erweiterung sichert das Ansehen des Komplexes als eines der führenden Einkaufszentren in Hong Kong. Hinzu kommen der Anbau eines Boutique-Hotels, eines Wellness-Zentrums und eines 23-stöckigen Bürohochhauses. Die Fassade des Geschäftskomplexes ist ein transparenter Schleier aus vertikal „gefalteten" Glasscheiben.

Son extension confirme sa réputation de plus grand centre commercial de Hong Kong. Y sont annexés un hôtel-boutique, un centre de remise en forme et un immeuble de bureau de 23 étages. La façade de ce complexe de magasins est constituée d'un voile transparent en vitres de verre aux « plis » verticaux.

La ampliación le asegura su reputación como uno de los centros comerciales a la cabeza en Hong Kong. A ello se suma la construcción de un Boutique-Hotel, un centro wellness y un edificio de oficinas de 23 plantas. La fachada de este complejo comercial se conforma como un velo transparente de placas de cristal "plegadas" verticalmente.

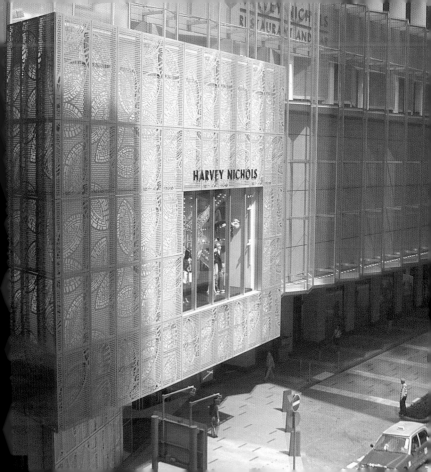

Index Architects / Designers

Index Architects / Designers

Index Structural Engineers

Index Districts

Index Districts

Photo Credits

9H 20, 30
Architectural Services Department 44, 46, 76, 78, 82, 84, 88, 94
Bertrand, Virgile Simon 30, 150, 158
Butlin, John 16
Chan, Charles 34
Chan, Raymond 144
Chang, Gary 54, 68
Chang, Howard 140, 144
Cheser-Ong, Andrew 50
Cheung, Franco K T 54
DISSING+WEITLING 90
Furniss, William 126, 164
Griffith, Tim 38
Ip, Kerun 40, 58, 80, 90
Kawano, Hiroyuki 170
Kunz, Martin Nicholas 106
Lau, Vitus 56
Leigh & Orange Ltd. 48, 72
Liesse 40
Liu, Dick 178
Mercer, Vera 98
Mok, Steve 142
Ong, Chester 108, 136
Prat, Ramon 160
Pottle, Jock 180
Rocco Design Ltd. 90
Sum, Bobby 74
Swire Properties Ltd. 62, 64, 110, 162
Sy, Joseph 18, 152
Tapan, Edgar 148
Tsang, Ulso 14, 118, 130, 138, 176
Uden, Graham 28, 36, 42, 172, 174
Wong, C.K. 60
Woods, Stuart 22, 156
Yip, Richard 32
Yeung, Roland 70
Ympa, Herbert 100

Victor Lam,
Vince Loden & Josef Gartner & Co. (HK) Ltd. 72

Other photographs courtesy
Animator: Symmetry (92), Cafe Deco Group (134), dbox (52), Superview (52), DR (120), Framewerkz (122, 124), Four Seasons Place Hong Kong (24), Gaia Group (126), OPIA (132), I.T Pacific Place (166), InterContinental Hong Kong (100), JIA Hong Kong (102), KPF (180), Lane Crawford (168), Langham Place Hotel, Mongkok, Hong Kong (104), Mandarin Oriental Hotel Group (112, 128, 146), OVO home & garden (174), Pacific Place Properties (28), Two IFC (66)

Imprint

Copyright © 2006 teNeues Verlag GmbH & Co. KG, Kempen

Published by teNeues Publishing Group

teNeues Book Division
Kaistraße 18
40221 Düsseldorf, Germany
Phone: 0049-(0)211-99 45 97-0
Fax: 0049-(0)211-99 45 97-40
E-mail: books@teneues.de

teNeues Publishing Company
16 West 22nd Street
New York, N.Y. 10010, USA
Phone: 001-212-627-9090
Fax: 001-212-627-9511

teNeues France S.A.R.L.
4, rue de Valence
75005 Paris, France
Phone: 0033-1-55 76 62 05
Fax: 0033-1-55 76 64 19

teNeues Publishing UK Ltd.
P.O. Box 402
West Byfleet
KT14 7ZF, UK
Phone: 0044-1932-403 509
Fax: 0044-1932-403 514

teNeues Ibérica S.L.
c/ Velázquez, 57 6.°
28001 Madrid, Spain
Phone: 0034-657-13 21 33

teNeues
Representative Office Italy
Via San Vittore 36/1
20123 Milan, Italy
Tel.: 0039-(0)347-7640551

Press department: arehn@teneues.de, Phone: 0049-(0)2152-916-202, www.teneues.com

ISBN–10: 3-8327-9125-6
ISBN–13: 978-3-8327-9125-4

Bibliographic information published by Die Deutsche Bibliothek.
Die Deutsche Bibliothek lists this publication in the Deutsche Nationalbibliografie;
detailed bibliographic data is available in the Internet at http://dnb.ddb.de.

Concept of and:guides by Martin Nicholas Kunz
Edited by Katharina Feuer, Anna Koor
Editorial coordination: Katharina Feuer
Layout: Katharina Feuer
Imaging & pre-press, map: Jan Hausberg

Texts written by Anna Koor
Translation: SAW Communications, Dr. Sabine A.
Werner, Mainz
Dr. Suzanne Kirkbright (German), Brigitte Villaumié
(French), Silvia Gómez de Antonio (Spanish)

Fusion-publishing stuttgart . los angeles www.fusion-publishing.com

Printed in Italy

Legend

NORTH POINT

and : guide

Size: 12.5 x 12.5 cm / 5 x 5 in. (CD-sized format)
192 pp., Flexicover
c. 200 color photographs
Text in English, German, French, Spanish

Other titles in the
same series:

Amsterdam
ISBN: 3-8238-4583-7
Barcelona
ISBN: 3-8238-4574-8
Berlin
ISBN: 3-8238-4548-9
Chicago
ISBN: 3-8327-9025-X
Copenhagen
ISBN: 3-8327-9077-2
Hamburg
ISBN: 3-8327-9078-0
London
ISBN: 3-8238-4572-1
Los Angeles
ISBN: 3-8238-4584-5

Munich
ISBN: 3-8327-9024-1
New York
ISBN: 3-8238-4547-0
Paris
ISBN: 3-8238-4573-X
Prague
ISBN: 3-8327-9079-9
San Francisco
ISBN: 3-8327-9080-2
Shanghai
ISBN: 3-8327-9023-3
Tokyo
ISBN: 3-8238-4569-1
Vienna
ISBN: 3-8327-9026-8

To be published in the
same series:

Dubai
Dublin
Madrid
Miami
Moscow

Singapore
Stockholm
Sydney
Zurich

teNeues

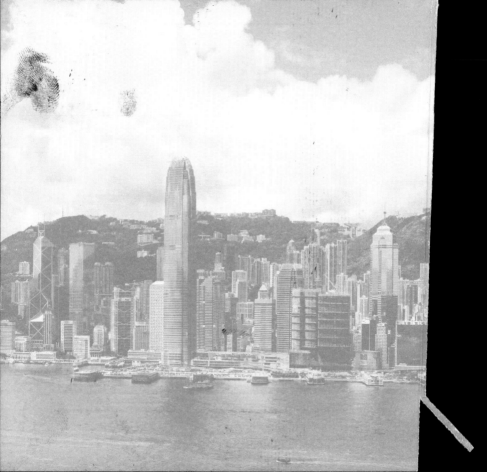